PAST & PRESENT

BRUNSWICK

OPPOSITE: In 1885, Ocean Lodge 214 laid the cornerstone for this new building at 1418 Newcastle Street. The Masonic temple occupies the second floor, with retail space below. The front facade was modernized in the 1950s. Like many Brunswick landmarks, it still stands proudly today. (Courtesy of Coastal Georgia Historical Society.)

PAST & PRESENT

BRUNSWICK

Suzanne Hurley and Joshua Dukes

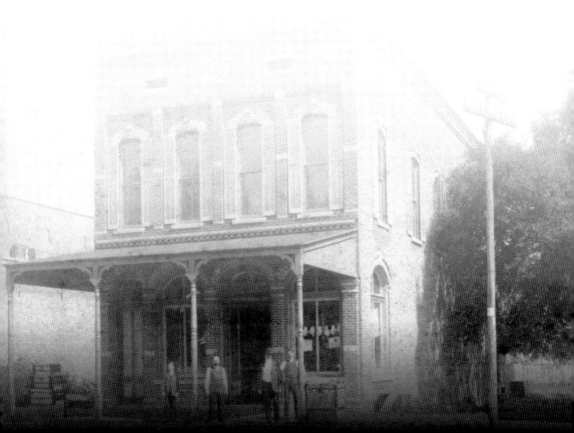

We dedicate this book to Charles Spottiswood Tait Sr., who is our inspiration for this project and the reason it exists. Thank you for your timeless images and for preserving them so that we can still enjoy them over 100 years later. We are so excited to share our Brunswick, both Charles's past and our present, with you in this book.

ON THE FRONT COVER: The Dunwody Building, at Newcastle and Gloucester Streets, takes its name from Henry Franklin "Harry" Dunwody, lawyer and former mayor of Brunswick. Tragedy struck on March 6, 1915, when Monroe Phillips entered Dunwody's office and shot him at point-blank range over $75 and a shipping barge sale. A fire in 1928 destroyed the original timber building, and Dunwody's widow, Scotia Dunwody, rebuilt it with brick. The building still carries the Dunwody name on the front facade. (Past, courtesy of Bryan Thompson; present, courtesy of the authors.)

ON THE BACK COVER: An excited crowd gathers to tour the new Glynn County Courthouse, which opened to the public for the first time on New Year's Day 1908. Prior to its completion, court was held on the third floor of 1419 Newcastle Street after a windstorm damaged the older courthouse at Queen Square in 1896. (Courtesy of the Charles S. Tait family.)

Contents

ACKNOWLEDGMENTS

The authors give a special thank you to the Darkroom Photography of St. Simons Island and its owner, John Toth, for support of this project. This book would not exist without them.

We have loved Brunswick's rich history since we first set foot in the Golden Isles. After Suzanne published *Great Houses of Brunswick* and Josh saw his Facebook group Golden Isles History explode in popularity, we knew we wanted to team up and share with everyone some of the great images we've discovered in our historical journeys.

Our initial inspiration for this book was Charles S. Tait Sr. (1861–1939), a turn-of-the-century businessman and talented local photographer. Charles meticulously preserved and documented his glass negatives, many of which are featured here for the first time. Charles was our inspiration for keeping this book close to turn-of-the-20th-century Brunswick, and we've limited any images taken after the 1920s. We thank the Charles Tait family for trusting us with his timeless images.

Bryan Thompson has our gratitude for the images he's provided to help us tell Brunswick's story. Marshes of Glynn Libraries have been an amazing partner to us, and we thank them for allowing us access to their Special Collections. Thank you to GuyNel Johnson and the Coastal Georgia Historical Society for double-checking our facts. John Hunter, Brunswick's director of planning, development, and codes, provided answers when we couldn't nail down some original locations, and we thank him for allowing us to continually pepper him with questions.

Josh would like to thank his husband, Jason, and his family for supporting deep dives into local archives, and he sends a special thank you to his high school history teacher Myrtle Rea Hanna for sparking his love of history with a family tree project that became an endless pursuit. Suzanne would like to thank her husband, Greg Zarus, for his enthusiastic support of her fascination with Brunswick history.

All current photographs were taken in 2023 and 2024 by the authors. Past images without notation are courtesy of the Charles S. Tait family; other sources are noted in the text.

INTRODUCTION

Brunswick, Georgia, is a small coastal city nestled at the westernmost point on the southeastern Atlantic seaboard. The city stands on a peninsula bordered on the west by the East River and on the east by St. Simons Sound, a deep-water harbor. To the south, the Brunswick River and the Intracoastal Waterway provide safe transport by water. The southern rivers separate Brunswick from its neighboring barrier islands. St. Simons Island and Jekyll Island guard the entrance to the harbor. These two island sentries along with Little St. Simons Island, Sea Island, and Brunswick itself are collectively known as the Golden Isles of Georgia. This protected location provides residents as well as shipping interests, recreational boaters, and fishermen with a safe harbor from hurricanes and other strong storms arriving from the sea. Today, the area is a renowned tourist destination boasting unparalleled natural beauty. Let's step back in time for a moment, though. Before anyone thought of visiting for beautiful photo ops and beach time, it was Brunswick's unique coastal location and access to abundant natural resources that set the stage for an explosive economic boom at the turn of the 20th century.

Plug Point was the original English name of Brunswick's peninsula. It was established as a tobacco plantation in 1738 by Mark Carr, the area's first European settler. Carr eventually sold the fields to the Province of Georgia in 1771, and Brunswick was born. The city was laid out from a design by Gen. James Oglethorpe, and it featured a gridded pattern of streets and repeating public green spaces. General Oglethorpe christened the new city in honor of Braunschweig, Germany—the ancestral birthplace of Britain's King George II. The Oglethorpe Plan was also used in Savannah. In 1789, Brunswick was made one of five ports of entry for the 13 states, and tall ships were able to gain access to the harbor for the first time.

Before the Civil War, growth was slow in the area. One sawmill operated in Brunswick with two more on St. Simons Island. Mainland workers traveled every day between Brunswick and the island on mill boats. Longleaf pine trees cut by logging crews in upland forests were loaded into rafts and floated down the Altamaha River and other southern waterways to be processed into lumber, rosin, and turpentine at coastal mills. Tall sailing ships from all over the world docked at the Brunswick port and Gascoigne Bluff, and their numbers continued to increase. By 1869, Brunswick was truly a shipping town, and Mayor James Houston noted Brunswick as "the safest, most capacious and best situated harbor on the southern Atlantic coast." From the late 1800s to the early 1920s, the mills processed so much lumber that they closed when the vast forests of longleaf pine were depleted by logging. It was this industry that set the stage for Brunswick's coming Gilded Age.

In 1880, the fledgling town had a population of only 2,800. Unlike many other southern cities during the Reconstruction period, Brunswick experienced an economic boom. The city became a source for transporting pine products, known as naval stores. The wealth of naval stores and timber and the jobs those industries created led to an explosion of waterfront

facilities, docks, and supporting businesses downtown. New homes for the wealthy and the working class followed suit. As the building boom followed the rise in fortunes, the captains of industry competed with one another to build large residences and community buildings worthy of the setting. During the turn of the century, many businesses and residential homes boasted a Victorian architectural style.

At its peak in 1901, the Brunswick port shipped more lumber than any other South Atlantic port and was the second-largest shipper of naval stores in the world. From Brunswick to inland Georgia, new rail lines stimulated a sawmill boom, which was said to average one mill every two miles. By 1920, the population had skyrocketed to 14,400. At the time, the only way to reach St. Simons Island was by a ferry that left from a dock in Brunswick and arrived at a pier on the southern tip of the island. The trip to St. Simons took about an hour by ferry. In 1924, the F.J. Torras Causeway was built as the first road and bridges connecting Brunswick and St. Simons Island. Passenger boat service between Brunswick and St. Simons Island slowly ceased as the new era of the automobile began. With easy access to the islands and their beaches, St. Simons eventually surpassed the smaller population in Brunswick and brought a new tourism economy to the area.

Brunswick's Gilded Age was witnessed and documented by Charles Spottiswood Tait (1861–1939), an amateur photographer and horticultural entrepreneur who also served as vice president of the Downing Company, a major naval stores business. From the 1880s through the 1920s, Tait photographed average daily life as well as major local events like the 1898 hurricane and the fire of 1896, which destroyed over half of the downtown businesses. He captured ships in port, tall ships at dock, children fishing, trains, and even cows crossing the street. He kept his photograph prints in tin cans at home and shared them freely with friends and family for entertainment. Taking a photograph at that time involved a large format camera, glass negatives, precise timing to capture the image, and manually developing prints from the glass negatives. If one looks closely at his images and the others featured in this book, one can glimpse the past in ways rarely captured. Windows were open, dresses were long, hats were worn outdoors, and fireplaces warmed the house. People walked, rode bikes or horses, or took boats for transportation. In the harbor photographs, one can see the hard labor involved in moving large barrels as well as workers toiling on ships that would soon travel to far-off destinations. One can also see time passing when technology changed, as sailing vessels gave way to steamboats and horses were replaced by cars. The once-crowded waterfront of large sailing ships and turpentine barrels in Tait's day has been replaced with the Georgia Port Authority at Mayors Point, a riverfront public park, and a private marina for pleasure boats. There is also a major Brunswick port on the Turtle River that handles vehicle shipping known as roll-on/roll-off shipping.

The original Oglethorpe Plan still exists today in the Old Town neighborhood, which is still blessed by an abundance of enormous live oaks with their moss blowing in the ocean breezes. Many original commercial and municipal buildings and several hundred restored houses have withstood the test of time and stand proudly along the public squares and among the live oaks. Old Town Brunswick and its surrounding neighborhoods continue to experience a renaissance with new businesses and renovations of its homes and public squares. Brunswick continues to meet its small-town challenges with optimism, community, and pride for its unique charms.

THE TOWN

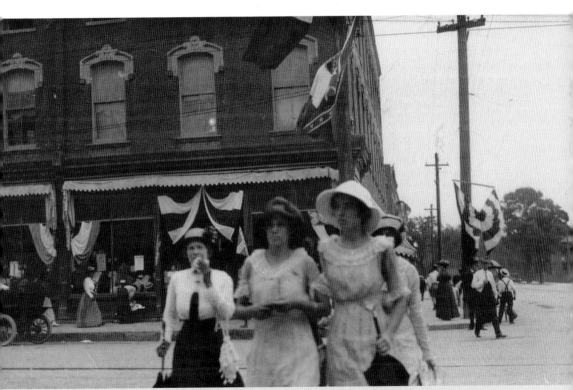

A group of well-dressed women carrying parasols enjoyed a parade in front of the A. Kaiser & Brother store at the corner of Newcastle and Gloucester Streets. The Kaiser Building was the first brick block in Brunswick and an early sign of changing times to come. (Courtesy of Bryan Thompson.)

Almost every commercial building in Brunswick was wood-frame construction in the early days. This late-1870s image depicts a post office and boardinghouses that occupied the northeast corner of Newcastle and Gloucester Streets. A series of fires in the 1880s claimed many of those original structures, including this entire city block. It was rebuilt as a series of brick buildings known as the Kaiser Block. (Past, courtesy of Bryan Thompson.)

THE TOWN

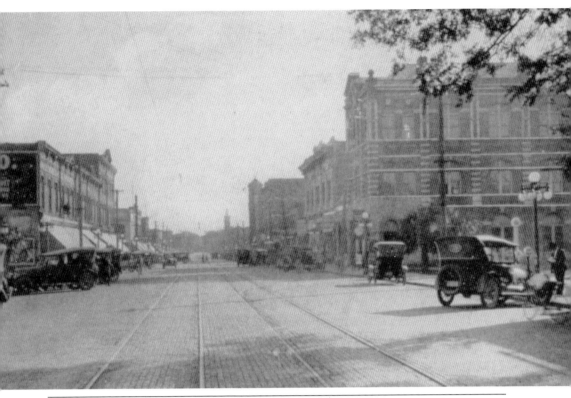

This view looking south on Newcastle Street from Machen Square features double streetcar tracks. Brunswick's streetcars first went into service on September 20, 1909, and continued until 1925. The three-story building on the right is the National Bank of Brunswick, which was torn down in 1958 when the Kress store expanded into the bank's footprint. Today's Newcastle Street features a cooling tree canopy and a green median. (Past, courtesy of Josh Dukes.)

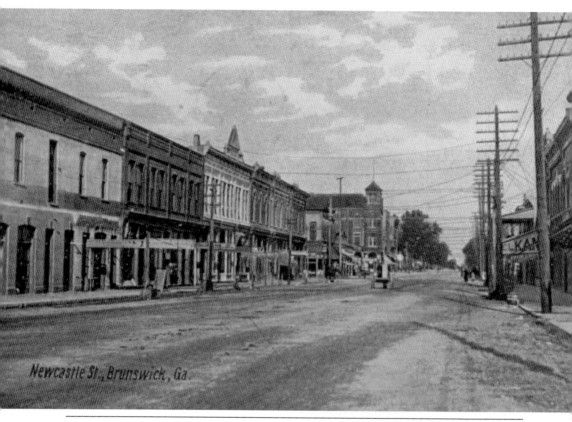

Newcastle St., Brunswick, Ga.

Newcastle Street was once an unpaved boulevard as seen here looking north from Queen Square. The c. 1880 building on the far left housed the Bijou Theater, an early movie house. Fire destroyed half of the building in 1983. Today, a median of palmetto trees graces Newcastle Street, and overhead lines are buried. A revitalization of this block now features an event venue in the Bijou footprint with Silver Bluff Brewing occupying the north end. (Past, courtesy of Josh Dukes.)

THE TOWN

The intersection of Gloucester and Newcastle Streets was the hub of city activity at the turn of the 20th century. Looking east on Gloucester Street, the Kaiser Block is to the left as well as the newly completed custom house and post office. Today, the custom house serves as Brunswick's city hall. While the buildings on the left leading down to city hall have all been replaced, the buildings on the right remain intact today. (Past, courtesy of Josh Dukes.)

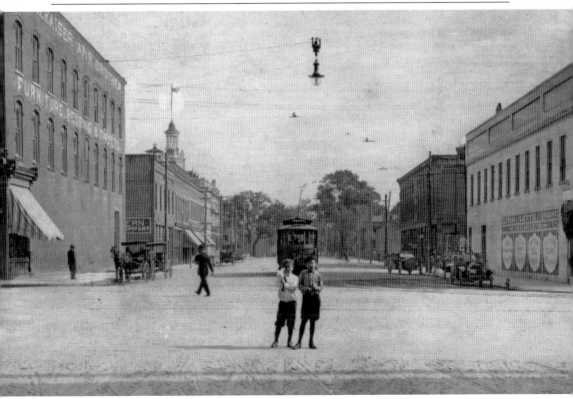

The Oglethorpe Hotel was built in 1888 on Newcastle Street with plans drawn up by architect John A. Wood. For many years, it served as a stopping-off point for wealthy travelers making their way to Jekyll Island for the winter. In 1958, mounting costs and a lack of available investors led to the hotel's demise. The Oglethorpe was replaced by a modern motel and JCPenney. The building remains; however, there are plans to redevelop the block. (Past, courtesy of Josh Dukes.)

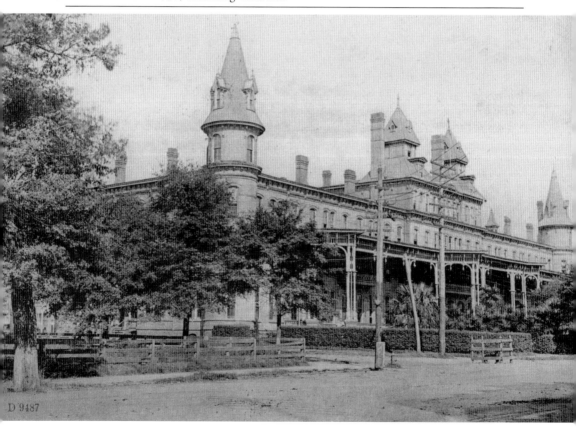

D 9487

THE TOWN

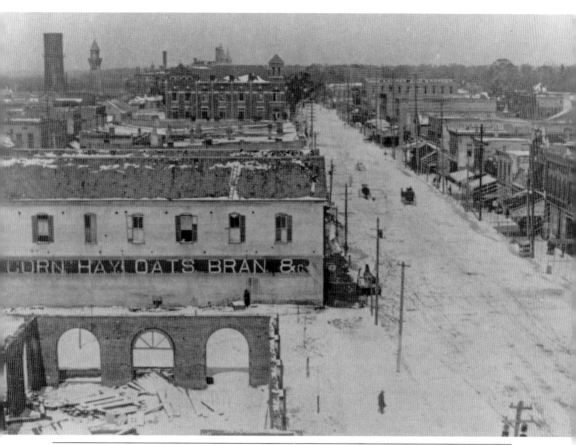

This bird's-eye view from Old City Hall's clock tower shows a rare snowfall in 1892. On the horizon are a chimney at the Mutual Light and Water Company and the Oglethorpe Hotel's water tower. A city market in the foreground began construction on Queen Square's northwest quadrant but was never fully realized. The structure remained abandoned before its removal in 1903. Today, only Old City Hall occupies one of the square's four quadrants. (Past, courtesy of Marshes of Glynn Libraries.)

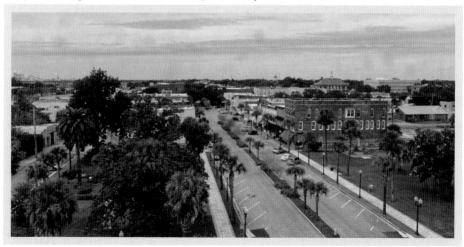

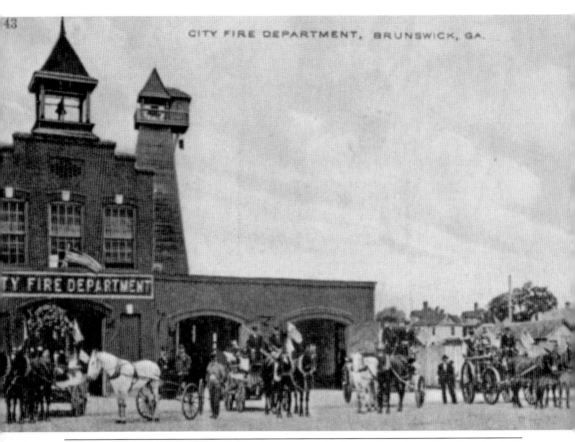

CITY FIRE DEPARTMENT, BRUNSWICK, GA.

Brunswick's volunteer fire company began work at its new headquarters on Queen Square in 1876. Horse-drawn wagons with alarm bells pulled water tanks. These were steam engines, with names like *Viola*. By 1890, the city enlarged the fire station and added a paid squad. This staff fought the fire of 1896, which engulfed the port docks and warehouses. In 1914, the department purchased motorized vehicles, and in 1932, it moved to today's headquarters on Gloucester Street. (Past, courtesy of Marshes of Glynn Libraries.)

THE TOWN

The City Hospital building was occupied around 1888 at the corner of First Avenue and Norwich Street. Around 1907, an addition was added to the south to bring the total bed count to 65. A new hospital opened in 1954 on Parkwood Drive. The original part of the hospital was in disrepair and was torn down. The newer hospital addition still stands today and is now the Brampton Lofts condo buildings. (Past, courtesy of Josh Dukes.)

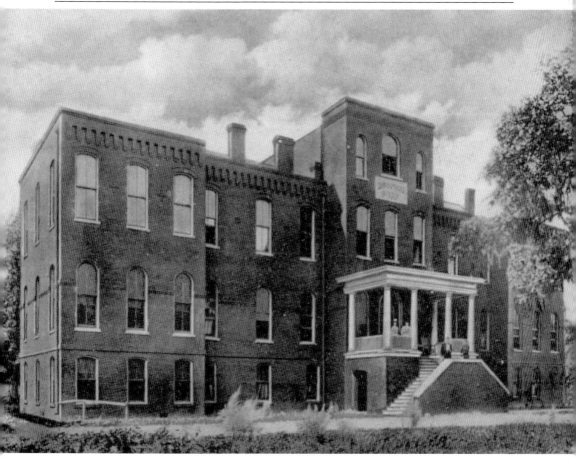

Georgia poet Sidney Lanier wrote his famous poem "The Marshes of Glynn" beneath this tree, Lanier Oak, drawing inspiration from the view in the 1870s. Helen Keller, a fan of Lanier's poetry, once visited the tree and said, "As I stand here and feel the tree and get the breath of the marshes, I am greatly inspired." Glynn Avenue was widened in 1952 and now straddles the tree. A small park still allows visitors to visit Lanier's Oak today.

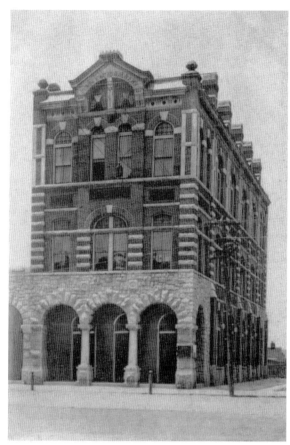

The National Bank of Brunswick was chartered in 1884, and this grand building was erected on the side of Machen Square West in 1894 with plans by architect Alfred Eichberg. Eichberg designed Old City Hall and Temple Beth Tefilloh among other local landmarks. The building was torn down in 1958 to expand the H.S. Kress building next door. A recent reimagining of the building has brought a hotel space and new businesses to the Kress. (Past, courtesy of Marshes of Glynn Libraries.)

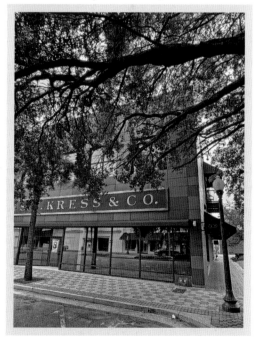

The Oglethorpe Bank was chartered in 1889, and it constructed this imposing building at Jekyll Square. The bank failed in 1893, and the building was alternately used as the Glynn County Courthouse, the Brunswick Savings and Trust Company, and the American National Bank. In December 1965, the top two floors of the building were removed. The arches of the original first-floor facade are still visible along Jekyll Square today. (Past, courtesy of Marshes of Glynn Libraries.)

Gloucester Street once featured many more residences like the two homes here, which sat east of St. Mark's Episcopal Church. Both of these properties fronted an entire block and were separated by Carpenter Street. In the mid-20th century, these houses were removed and a car dealership operated at Carpenter and Gloucester Streets. First United Methodist Church now owns this property and maintains an activity center with a dedicated greenspace. (Past, courtesy of Marshes of Glynn Libraries.)

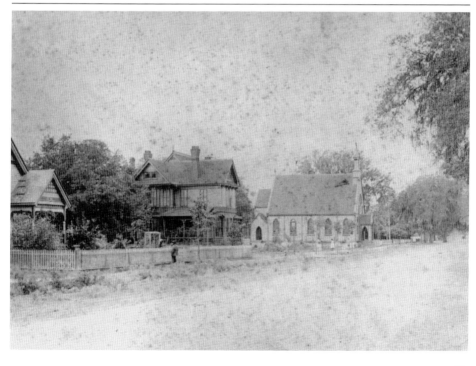

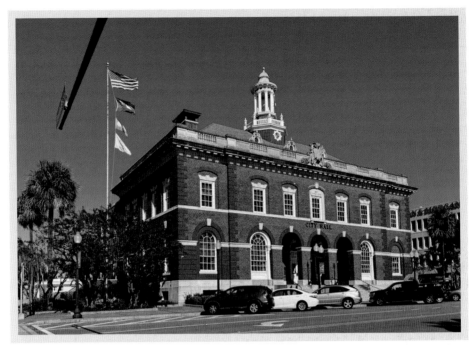

Brunswick City Hall, at 601 Gloucester Street, began as the US Custom House. A Bourke family home had been here and was offered for sale in 1901. James Knox Taylor with the Department of the Treasury supervised the building. The post office began operations in 1904. The city purchased the building in 1951, and after a new post office was completed, city hall relocated here.

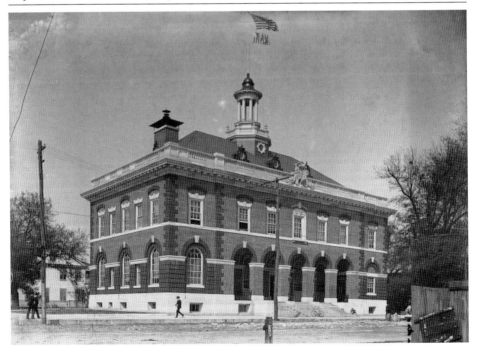

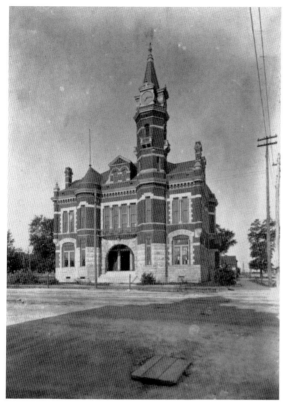

Designed by Georgia architect Alfred Eichberg, Brunswick's Old City Hall was completed in 1893 in the Richardson-Romanesque style. The original tower was removed in June 1951 after years of weather damage. In 1964, city hall moved to the former custom house and post office building on Gloucester Street with some offices remaining here. In 2003, the city restored the clock tower to its original appearance and height. Today, Old City Hall hosts city commission meetings, receptions, and private events.

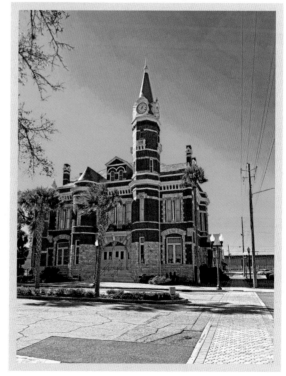

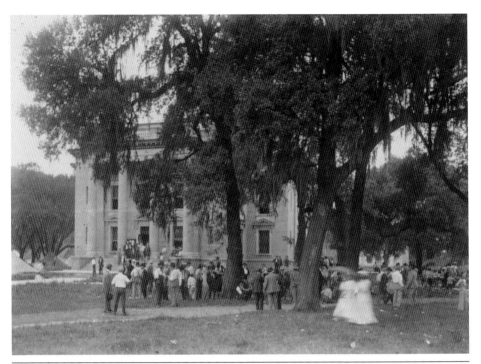

In 1907, a crowd celebrated the newly completed Glynn County Courthouse at H and Reynolds Streets. The building was designed by New York City architect Charles Alling Gifford, who also designed much of the Jekyll Island Club. Recent construction materials are visible beside the building. Influenced by the American Renaissance Revival style, the building has neoclassical window details with terra-cotta window frames. The courtrooms have balconies, built as a result of racial segregation. Today, the grounds include acres of palms, magnolias, and live oaks.

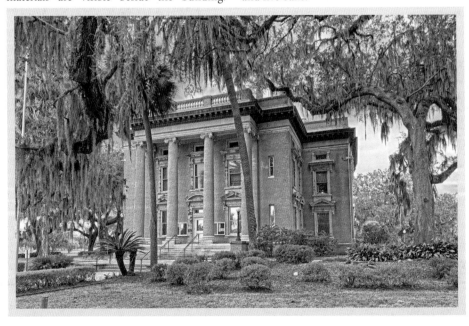

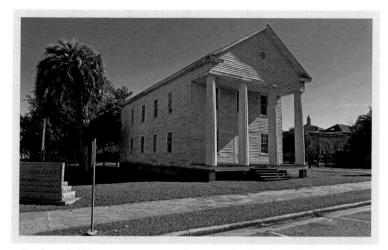

The Glynn Academy building was constructed at Hillsborough Square in 1840 and remained the only public school in Brunswick until the 1890s. It originally faced Egmont Street and featured a cupola. In 1915, this building was moved to Sterling, Georgia, where it was used as a school for African American children. In 2008, the old school was relocated to Glynn Academy's campus, and the building now sits at the corner of Norwich and Monck Streets.

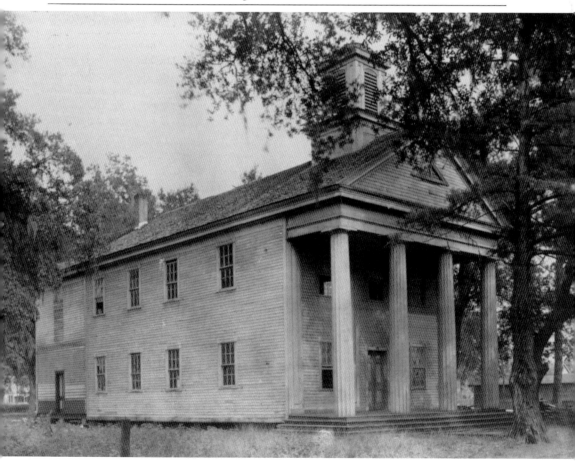

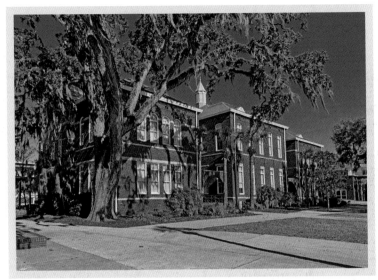

To meet the demand of the growing Brunswick student population, a two-story brick building known as the Annex Building was designed by Alfred S. Eichberg and erected in 1889. Constructed on Mansfield Street as three buildings in one to promote airflow and prevent fire, each section was joined by an arched entrance. The annex was replaced by the main Glynn Academy building in 1923 and was virtually dormant until 1938, when it was renovated for additional student classes.

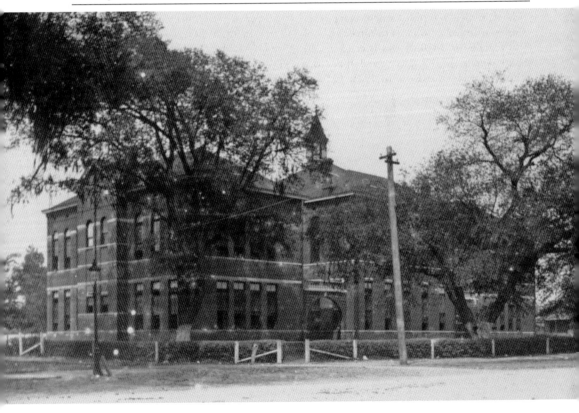

Colored Memorial School and Risley High School formed a historic school complex at 1800 Albany Street, where a freedmen's school was founded in 1870. It was later named to honor Union soldier and school fundraiser Capt. Douglas G. Risley. In 1923, Colored Memorial High School was built and named to honor African American veterans in World War I. In 1955, Brunswick built a new Risley School, which is on the National Register of Historic Places. (Past, courtesy of Marshes of Glynn Libraries.)

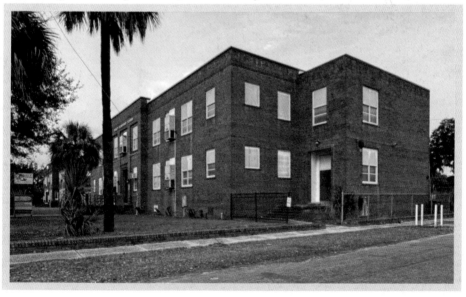

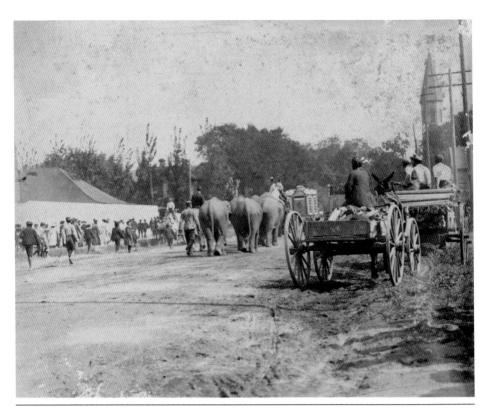

This parade scene shows Mansfield Street's packed-dirt streetscape looking east from Newcastle Street. Brunswick First Baptist Church's steeple, visible to the right side of the old photograph above the trees, moved its new sanctuary across Mansfield Street, where the new steeple is visible, in the mid-20th century. The City of Brunswick's annex building replaces the sewer pumps and chimney to the left.

The property at 1430 Newcastle Street was built around 1880 at the southeast corner of Newcastle and Gloucester Streets. It is reportedly the oldest surviving brick building in the downtown corridor. The building was a response to fires that claimed a large portion of downtown and was touted as fire resistant. The adjoining buildings complete one of the most intact original brick blocks remaining today. (Past, courtesy of Bryan Thompson.)

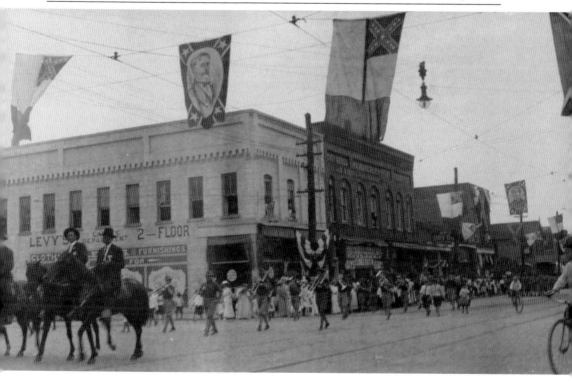

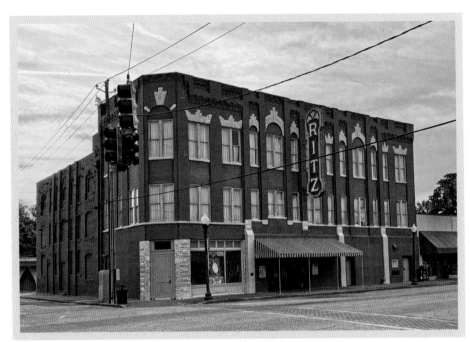

The Grand Opera House was constructed in 1898. The three-story front offices were the headquarters for the Brunswick & Birmingham Railroad. In the 1930s, the theater was converted to the Ritz Theater for films and the facade was remodeled to an Art Deco style. The building fell into disrepair, and the City of Brunswick purchased the Ritz in 1980. The theater was remodeled for stage shows, with performances still booking the theater today. (Past, courtesy of Golden Isles Arts and Humanities.)

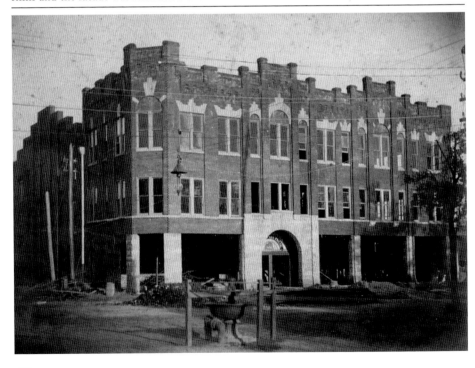

The building on the right was built around 1890 at 500 Gloucester Street and sat on the corner of Richmond Street. Its many street-front stores housed various businesses over the years, including furniture and jewelry shops around the turn of the 20th century. A boardinghouse offered rooms to rent on the second floor, and in the 1950s, it operated as the Wesley Inn. The building continues to provide varied retail space on Gloucester Street today.

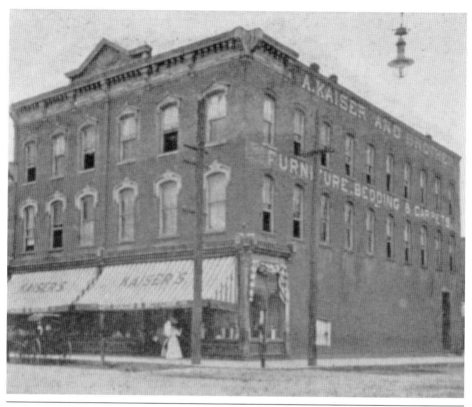

German-born brothers Arnold and Michaelis Kaiser founded A. Kaiser & Brother Mercantile in 1875 and opened their new three-story building on the corner of Newcastle and Gloucester Streets in 1884. It was lit by 50 modern gas fixtures. A.J. Gordon purchased the building in 1922 and later modernized the facade. In 1976, plans to renovate the structure revealed a bad foundation, and the Gordon Building was torn down. A two-story building was erected in its place. (Past, courtesy of Marshes of Glynn Libraries.)

This c. 1915 view of Newcastle Street looking south shows how many three-story buildings downtown once boasted. To the left is the Kaiser Building. Old City Hall's distant clock tower is on the horizon. The tall square tower is the Oglethorpe Bank Building at 1419 Newcastle Street, followed by 1423 Newcastle Street, 1435 Newcastle Street, and finally, the detailed stonework of the Bank of Brunswick on the far right. Only 1423 and 1314 Newcastle Street retain three floors today. (Past, courtesy of Shayne Woodard.)

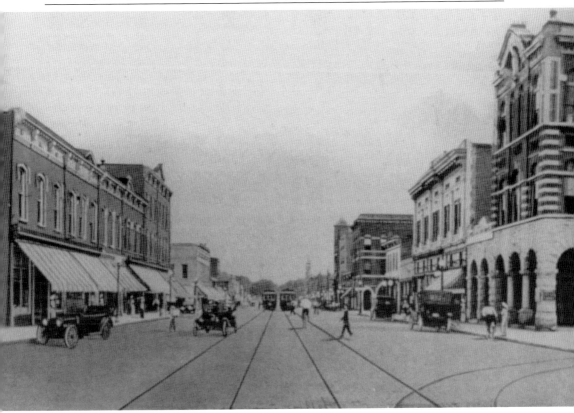

German-born pastry chef George A. Faber (1878–1917) operated his Faber's Bakery in two locations: 1614 Newcastle Street and this location at the corner of Newcastle and Monck Streets. Faber's Bakery specialized in cream puffs, cakes, and pastries and was touted as the only steam-baking establishment in this part of Georgia. The original facade included a small second-floor balcony above the sidewalk. Today, this is the home of Brown's Antiques. (Past, courtesy of Marshes of Glynn Libraries.)

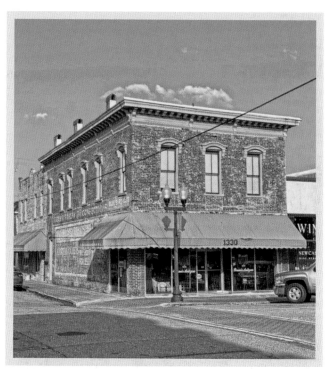

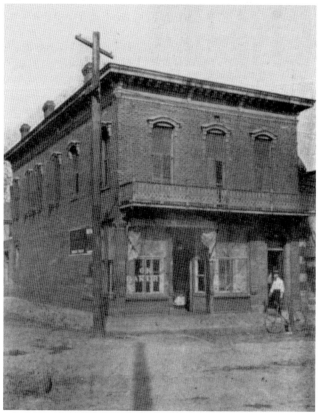

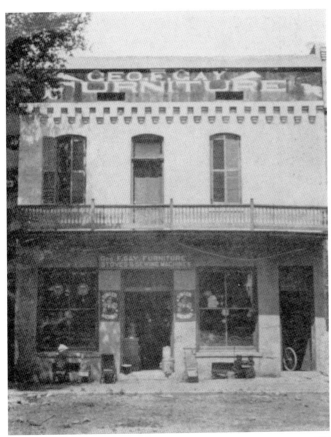

From his storefront at 1602 Newcastle Street, George F. Gay sold home goods including stoves, sewing machines, and furniture. The store operated for nearly 20 years before Gay died after a short illness in 1915. The business was reorganized as the Gay Furniture Company. Today, this storefront is home to the Rose & Vine. (Past, courtesy of Marshes of Glynn Libraries.)

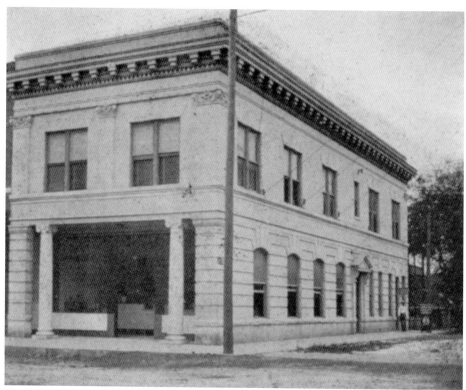

The Glynn County Bank opened this building at the corner of Gloucester and Reynolds Streets in 1907. The furnishings were handsome and elaborate, made of mahogany and Italian marble. In 1920, the bank and courthouse were robbed by S.G. Goodbread, C.L. Davenport, and William Zant. The robbery took place at night, with the teller only discovering the scene the next morning. The front portico was modified prior to 1972. (Past, courtesy of Marshes of Glynn Libraries.)

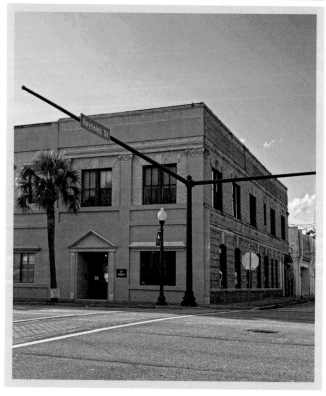

THE HOMES

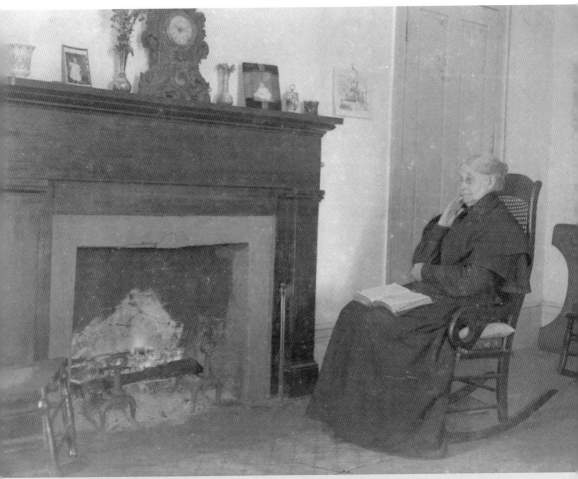

This glimpse of the Tait family home on Dartmouth Street includes a cozy fireside spot that provided a respite from the day. Most of Old Town Brunswick's homes were constructed between 1880 and 1910. Over the years, some were lost to fires, storms, progress, or tragically to neglect. Fortunately, a majority of the historic neighborhoods are still intact today.

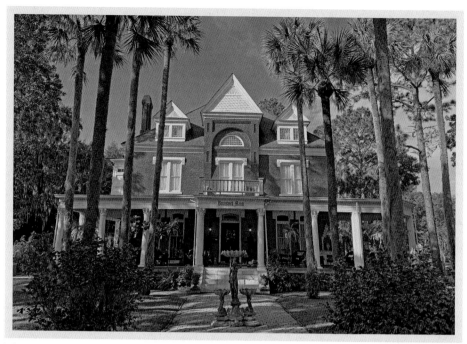

The Columbia Downing House, at 825 Egmont Street, faces Halifax Square and was built for the Downing family by Fay & Eichberg Company. Maj. Columbia Downing (1845–1924) was a major supporter of commercial and residential development. He chartered the National Bank of Brunswick in 1884. In 1890, he also founded the Downing Company, a naval stores business. The Corinthian columns were added in 1910. Now it is home to Brunswick Manor, an imposing and renovated bed and breakfast.

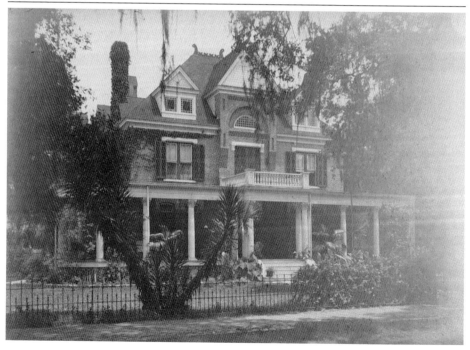

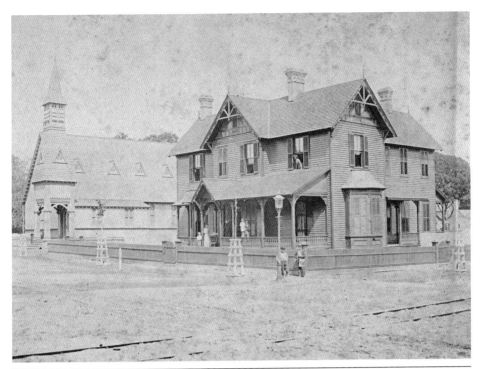

The house at the corner of George and Union Streets was built in 1887 as the manse for the First Presbyterian Church. It was later used for Sunday school and youth group meetings. In 1952, the manse was relocated across Union Street to make room for a new classroom building. The house now sits at 1100 Union Street and is missing the three fireplaces. (Past, courtesy of First Presbyterian Church of Brunswick.)

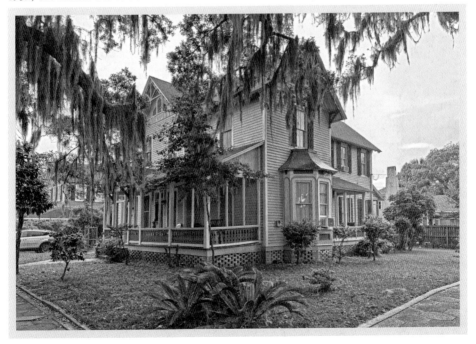

Prominent citizen Capt. Sam Brockington and his family once owned this home at 629 Norwich Street. Brockington was a harbor pilot on the Brunswick Bar from the 1890s until 1940. He came from a family of sea captains; Sam's brothers and his son Alfred were all pilots as well. In 1886, Captain Brockington purchased the land for this home as well as the lot next door.

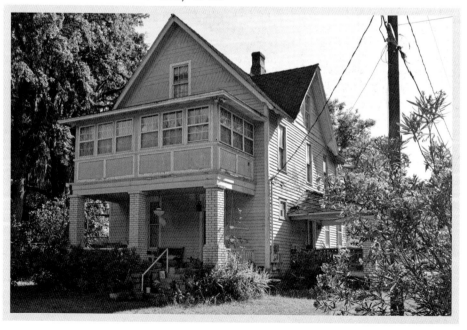

THE HOMES

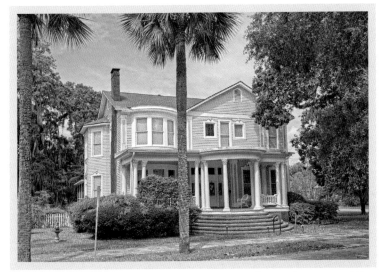

This grand home at 827 Union Street was built in 1901 by Joel and Gertrude Lott. Designed by George Barber, it was one of six Barber houses in Brunswick. It originally included a third-story living space, but the third floor burned in 1930 and was not replaced. Joel Lott owned several stores in Glynn County and was on the boards of the Brunswick Bank & Trust and the Brunswick & Birmingham Railroad Company. (Past, courtesy of Marshes of Glynn Libraries.)

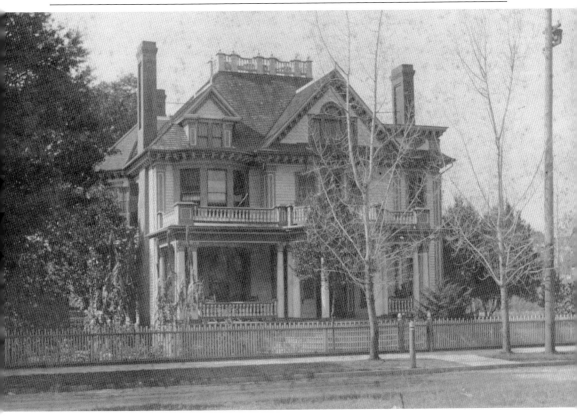

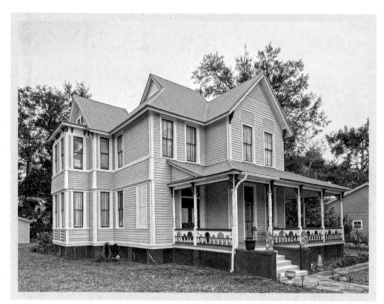

One of the larger Victorians in Brunswick today, 528 Newcastle Street was owned by Benito Padrosa. He served as president of the Columbia Lumber & Timber Company from 1890 to 1925. Padrosa's name was given to several barkentine ships from the era. The house maintains many of its original features today, with only the picket fence and the weather vanes missing.

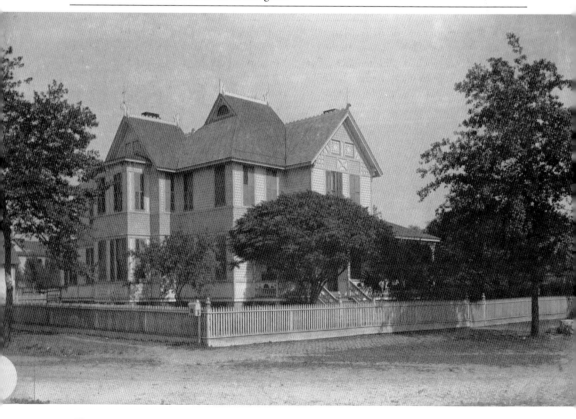

THE HOMES

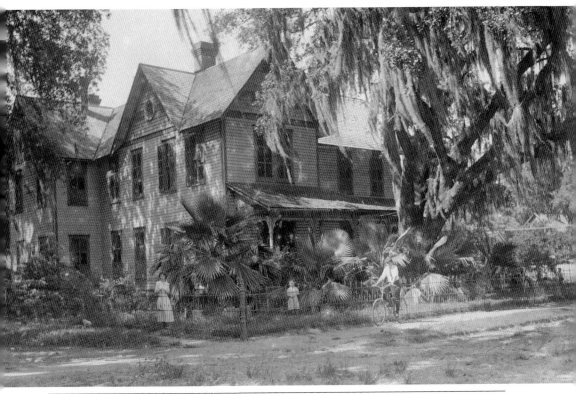

Charles S. Tait Sr. and his wife, Margaret, built this house at 903 Dartmouth Street in 1889 and raised eight children here. For over 44 years, Tait worked for the Downing Company as vice president and manager. He had a greenhouse in the back for plants he hybridized. Later, in the 1920s, Charles and Robert H. Parker bought New Hope Plantation south of Brunswick. He was also an early photographer, creating many of the historical images shown in this book and elsewhere.

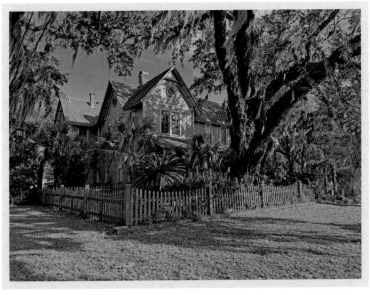

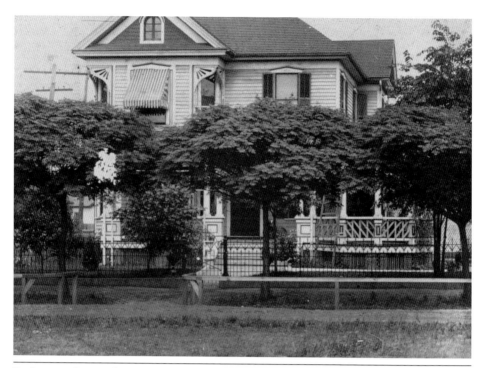

Built around 1875 by sea captain William M. Tupper, 1125 Union Street maintains its original iron fencing. Captain Tupper later decided the rooms were too small, so he built a larger house at 1127 Union Street. Tupper also operated transport businesses between Brunswick and Fernandina, Florida. His brother, also a sea captain, built a house at 1200 Union Street boasting beautiful double porches.

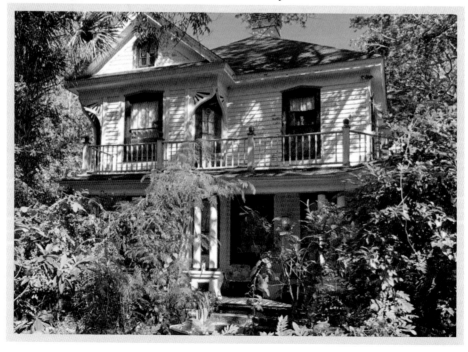

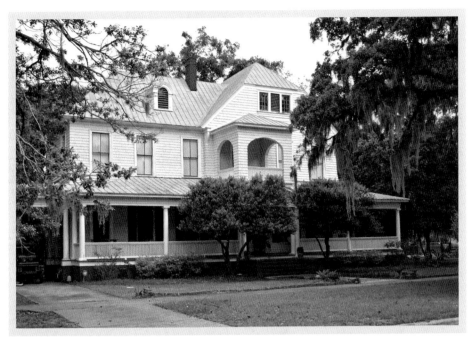

The Honorable William G. Brantley and his wife, Jesse, built this house and lived here with their three children. He was a member of the Georgia Senate and the US House of Representatives. After Jesse died, he married Mary Linn and had two more children, and the family remained here until 1913. The hurricane of 1898 destroyed parts of the house including the front porch, but the house was enlarged so that the shingled structure looks much different today.

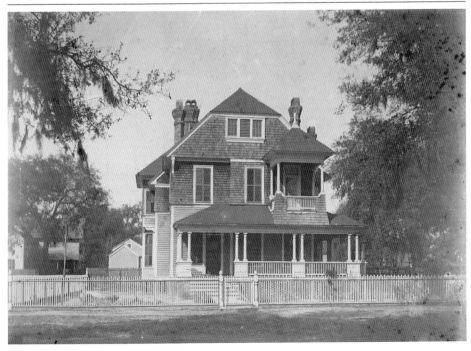

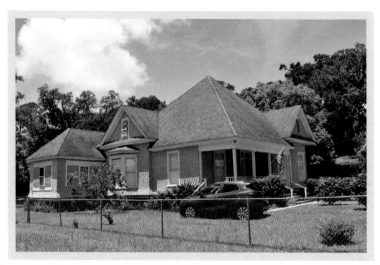

Located at 501 Wolfe Street, this cedar shingle–covered home originally had a hexagonal glass greenhouse full of plants. Indoor plants in homes were a new fashion at the turn of the 20th century. The greenhouse has since been walled in and covered with shingles. The Abbott family built this house around 1908. One of their sons, Cleveland V., was a county commissioner for Glynn County and manager of the Burns and Dickey grocery store on Gloucester Street.

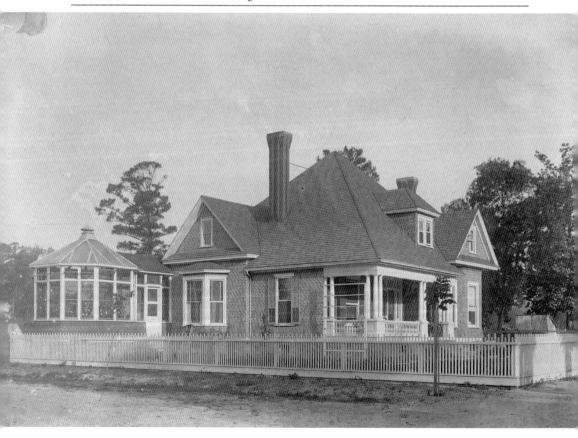

THE HOMES

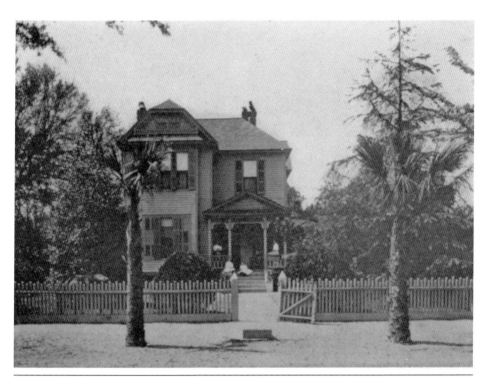

The home at 915 Egmont Street was owned by Herbert Miller, a native of Germany and owner of the H.M. Miller & Sons Furniture Company on Newcastle Street. Miller and his wife, Minnie, had several children who went into prominent work. Their son Edo Miller founded Edo Miller & Sons Funeral Home, which continues to serve Brunswick over 100 years later. (Past, courtesy of Marshes of Glynn Libraries.)

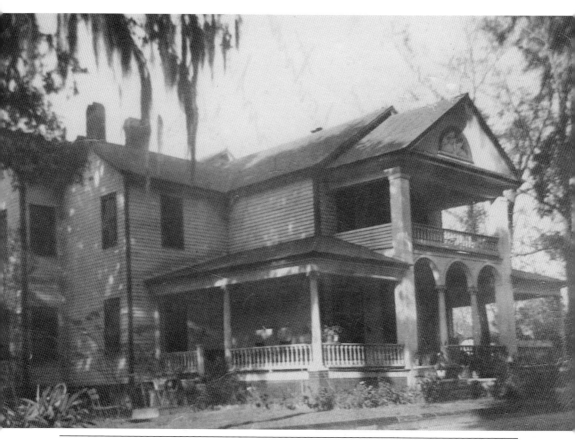

The J.W. Wade home, built in the Queen Anne style in about 1890, occupied the north end of Wright Square between Egmont and Norwich Streets and included several outbuildings. It was later remodeled into apartments. In 1952, the Wade family sold the property to allow the construction of Glynn Middle School on the north half of the square. Today, Wright Square is restored to its original size with Glynn Academy occupying the home's footprint. (Past, courtesy of Marshes of Glynn Libraries.)

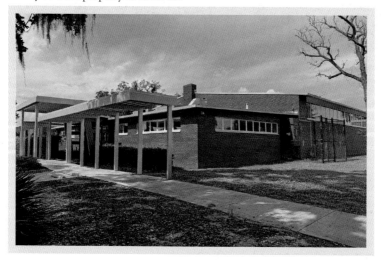

WORK AND INDUSTRY

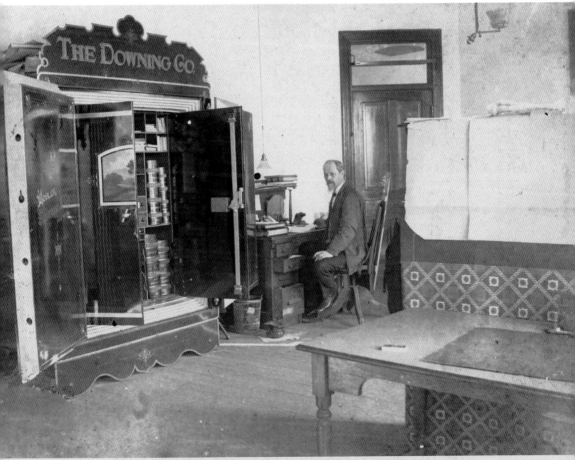

One of the most successful corporations in Brunswick's Gilded Age, the Downing Company dealt in naval stores and timber. At the company's headquarters on Bay Street, this magnificent safe certainly held valuables such as essential records and vast cash reserves. The naval stores industry was supported by many businesses that experienced rapid growth in Brunswick during this period.

In 1876, Brunswick's volunteer fire company opened its headquarters on Queen Square's southwest quadrant. The Brunswick City Jail and the Glynn County Jail are both visible beyond the trees to the left of the fire station. Both of these buildings faced Queen Square Northeast from Richmond Street. The City Jail was relocated in 1939, and the Glynn County Jail building later served as the Board of Health Headquarters before it was razed in 1953. (Past, courtesy of Marshes of Glynn Libraries.)

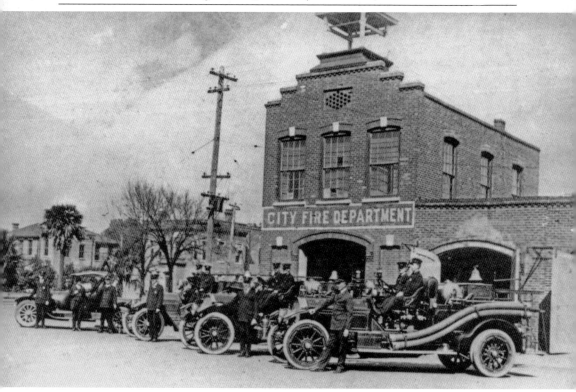

WORK AND INDUSTRY

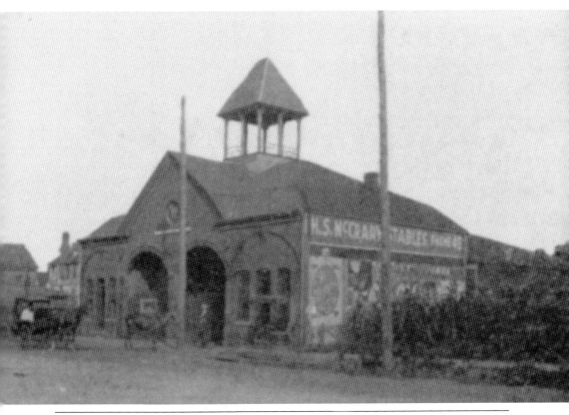

H.S. McCrary's livery stable, owned by Sam McCrary, was located on the corner of Mansfield and Reynolds Streets. One could rent a horse, buggy, wagon, or team at a livery. Workers shoed horses, repaired wagons, and mended wheels. Before cars, a livery stable was an essential trade in nearly every community. In 1930, Coca-Cola opened a bottling plant here that is still operating today. (Past, courtesy of Marshes of Glynn Libraries.)

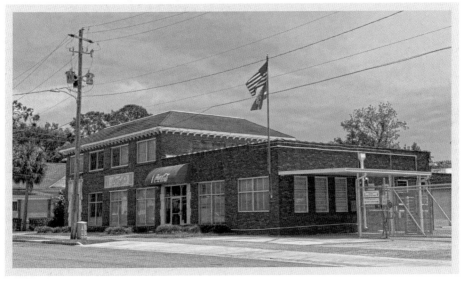

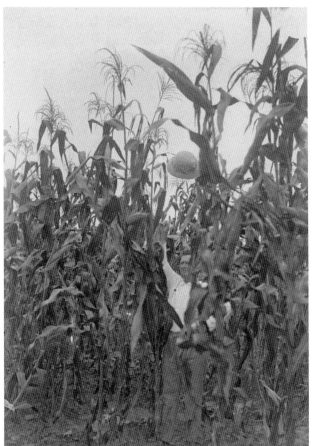

At New Hope Plantation, south of Brunswick, corn was grown along with rice and flower bulbs on the shores of the marshes. Here, New Hope co-owner Robert H. Parker throws his hat in this cornfield celebrating his corn harvest. The image also captured the hat at a point in motion, a new photography technique at the time. The view today shows the marshes, an important source of water for rice crops, in the distance through the trees.

These badly decaying marine rail docks were located at the foot of Prince Street. In the 1890s, the docks were a bustling lumber wharf operating as a branch of the Savannah-based Stillwell, Millen, and Company. Later, the wharf belonged to Charles H. Hirsch. Today, many local shrimp boats call this part of the waterfront their home port. (Past, courtesy of Bryan Thompson.)

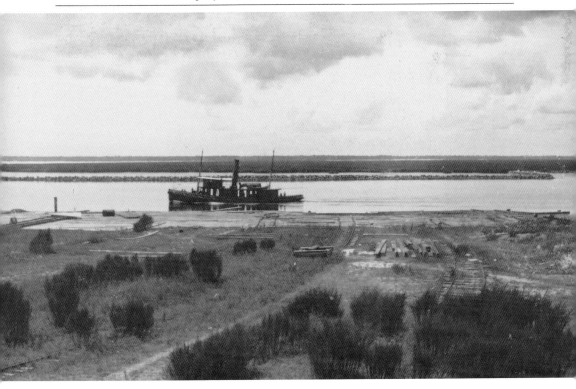

New Hope Plantation is located 10 miles south of Brunswick and was one of the last remaining rice plantations in Georgia still under cultivation at the turn of the 20th century. Charles S. Tait Sr. and his partner Robert H. Parker purchased over 650 acres here for growing flower bulbs. Tait is pictured here while photographing a worker and the expansive rice harvest. Today, only the live oaks remain in this field where the rice was stored.

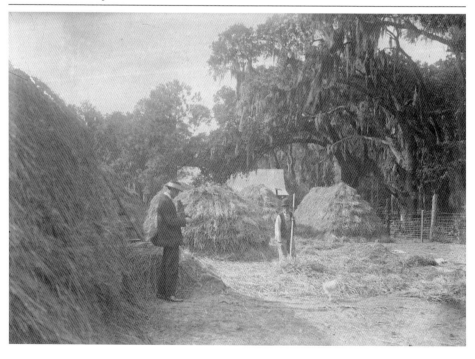

WORK AND INDUSTRY

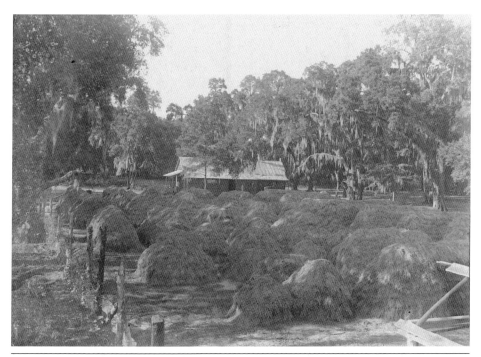

New Hope Plantation was still operating as a working rice plantation but transitioned to producing flower bulbs after Brunswick residents Charles Tait Sr. and Robert H. Parker purchased it in 1929. Tait's daughter Margaret Radcliffe recalled vast fields of amaryllis bulbs as well as narcissus and daffodils. Today, a small house sits on one part of the property. The land was recently acquired by a film company with plans for a film studio and other development.

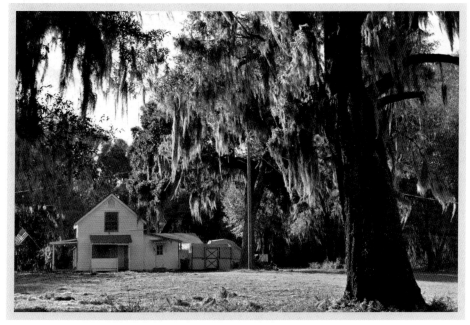

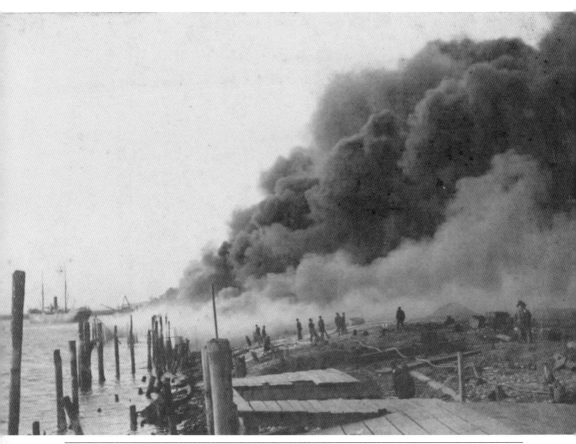

On April 2, 1896, a wayward flame from a pile driver ignited a blaze at the Downing Company docks on the East River. The docks were loaded with turpentine barrels for shipping and erupted in flames. Over 26,000 barrels of turpentine were destroyed. The tugboat *Inca*, on the left, was in place to help stop the fire with its fire pumps. Fortunately, all the barrels were insured. (Past, courtesy of Coastal Georgia Historical Society.)

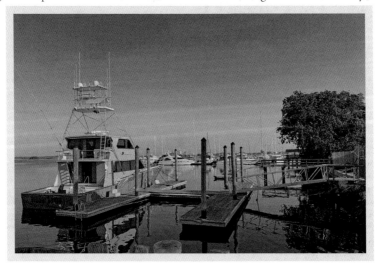

The Columbia Downing Barrel and Resin Company, on the East River, produced resin and turpentine. Columbia Downing served as president with Charles S. Tait Sr. as vice president. Charles is featured here taking photographs of the workers who worked with these resin barrels while his young son wanders about the area. Today, this area is part of the Brunswick Port and is operated by S&B Industrial Minerals.

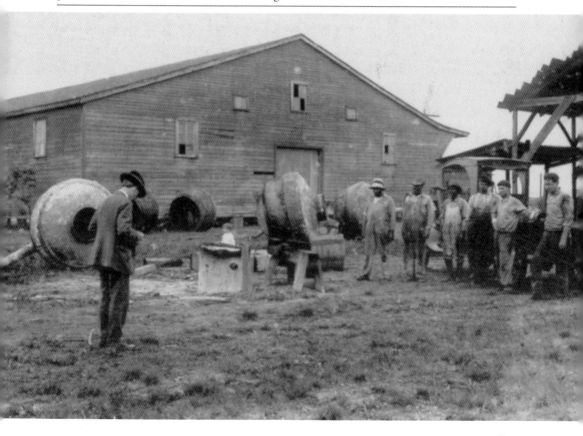

Brunswick's port was heavily trafficked by tall ships, as seen in this view of the East River in the 1890s. The masted sailing ship in front is loading lumber. Many companies operated wharf docks and supporting businesses for ships coming to the port. These tall-masted ships are calling at the Downing Company timber docks at the south end of the city.

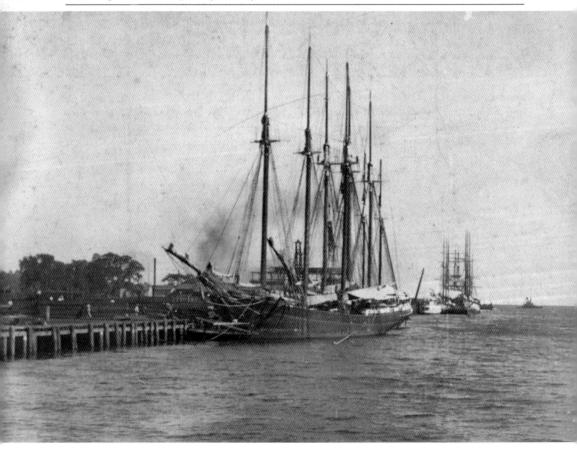

WORK AND INDUSTRY

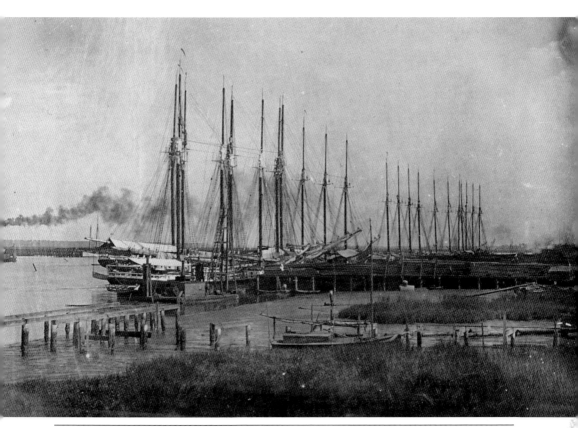

At the north end of the East River, many tall sailing vessels were doubled up at docks to collect naval stores and timber along one of the northern wharves. Docks and a ship are visible at the wharf at the north bend of Academy Creek before the waterway was blocked off. The number of ships indicates the enormous size of the naval stores industry at that time. Today, this area is the north docks of Brunswick Landing Marina.

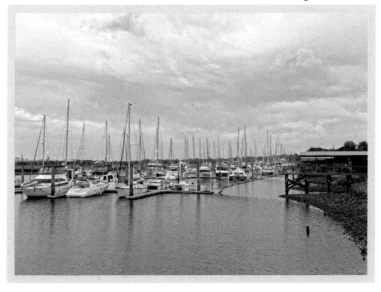

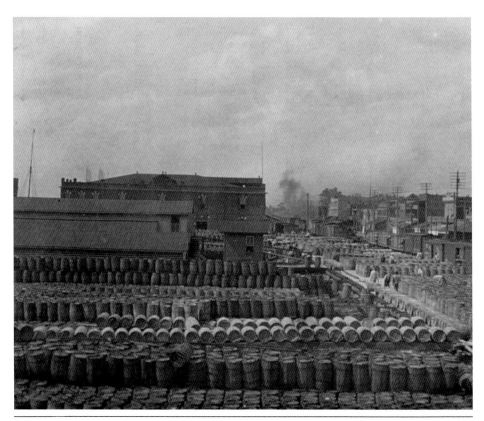

This expansive view north at the Downing Company's resin yard at the Brunswick Port includes the scene along Bay Street at the foot of Mansfield Street. A changing economy and the need for a larger port led to the removal of everything in this image in the 1960s. Bay Street was widened and moved a block east into the footprint of Oglethorpe Street, and the port expanded to the east along with it.

WORK AND INDUSTRY

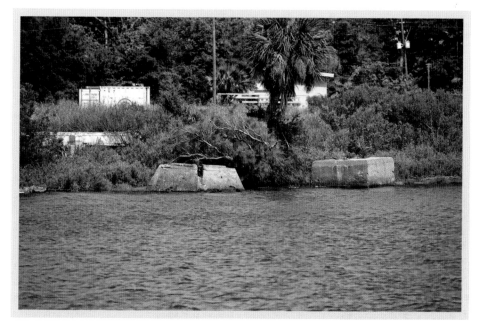

The Parker-Hensel Engineering Company is visible behind a dry-docked ship. The company was located along the port at the foot of Dartmouth Street. Helmed by Pres. A.R. Hensel, the company made boilers as well as employing founders and machinists. The site included a hoisting house for dry docking ships like this one. The dry dock is now filled in, with this portion of the waterfront fenced off and returning to nature. (Past, courtesy of Bryan Thompson.)

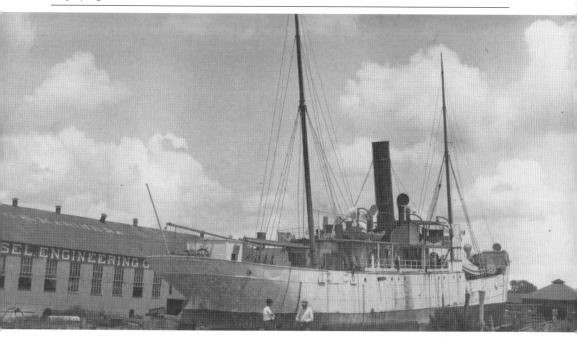

The Brunswick & Birmingham Railroad Company was chartered on December 11, 1900, and headquartered in the front offices of the Grand Opera House. It was purchased by the Atlantic & Birmingham Railroad in 1904, which the wall calendar in the photograph reflects. As early as 1930, many of the offices were converted to apartments, and these remained available through the 1950s. Today, these upper floors are storage for the Ritz Theater, which plans to restore them for future use.

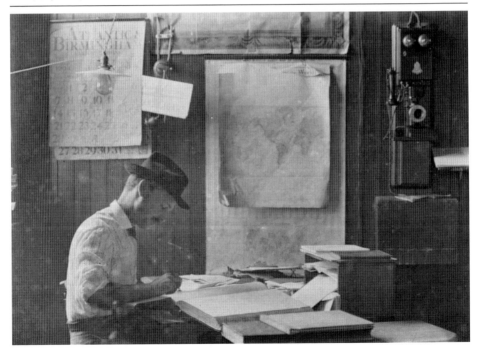

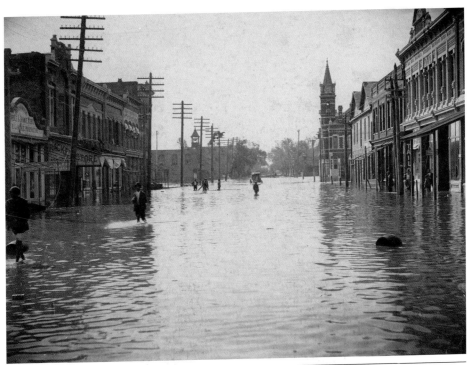

On October 2, 1898, a hurricane packing winds of 135 miles per hour made landfall on Cumberland Island just south of Brunswick. Even the city's protected location along the coast could not shield downtown from a massive 16-foot storm surge. The port, downtown businesses, and neighborhoods suffered major damage, and recovery was long. Today, the south end of Newcastle Street, seen here, still experiences some effects of tidal flooding during heavy storms. (Past, courtesy of Marshes of Glynn Libraries.)

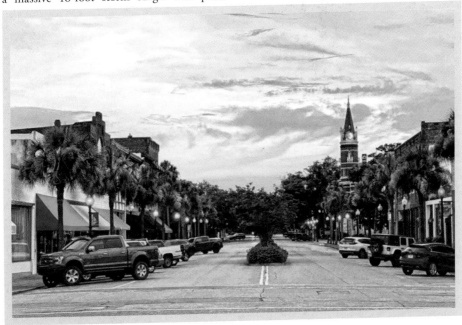

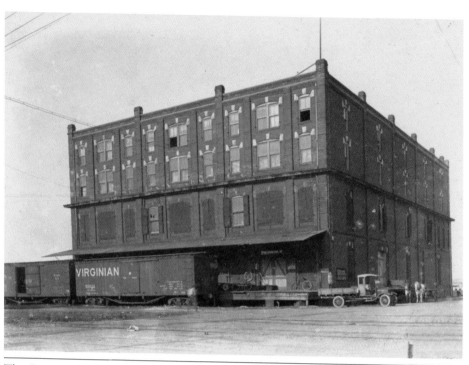

The Downing Company headquarters were located where Monck Street meets Bay Street. Columbia Downing first organized his company in 1882. The Downing Company was the first business in the United States to combine both naval stores and supplies under one management. It also supplied wholesale grocers and manufactured its own barrels. In 1974, the building was torn down to make way for a widening of the Georgia Ports Authority right of way.

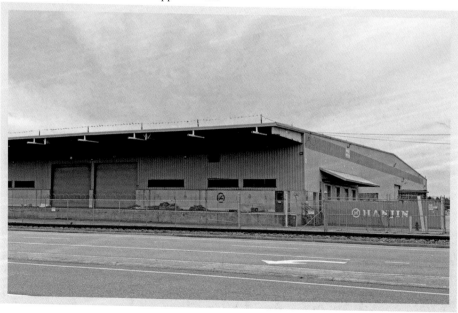

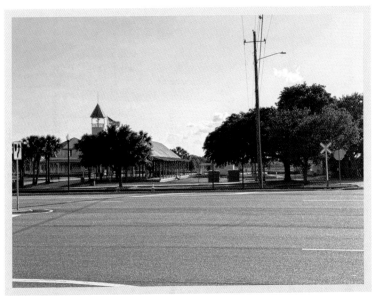

The Lott-Lewis Company, a wholesale grocery warehouse, was located at the corner of F and Bay Streets. When the port was expanded in the 1970s, Bay Street moved a block east into the footprint of Oglethorpe Street. All buildings between Oglethorpe and Bay Streets were removed. The original footprint of the building is in the middle of today's four-lane Bay Street.

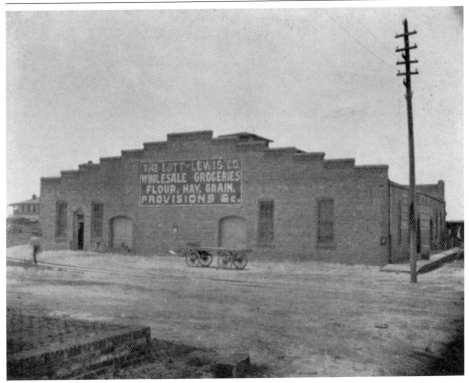

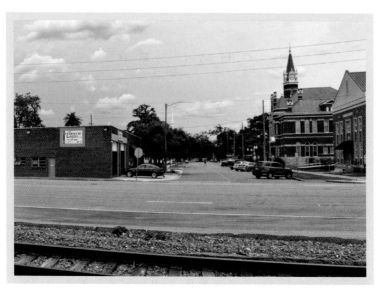

James B. Wright and Charles M. Gowen were ship chandlers specializing in groceries and hardware. They built this business at 1300 Bay Street facing the big industries at the port. By 1912, the building hosted other businesses in their spacious offices, including the Brunswick and Florida Steamboat Company, St. Simons Transit Company, the Brunswick Pilot Association, and the Oglethorpe Cigar Company. Charles Gowen was also a dentist with an office on Gloucester Street. (Past, courtesy of Marshes of Glynn Libraries.)

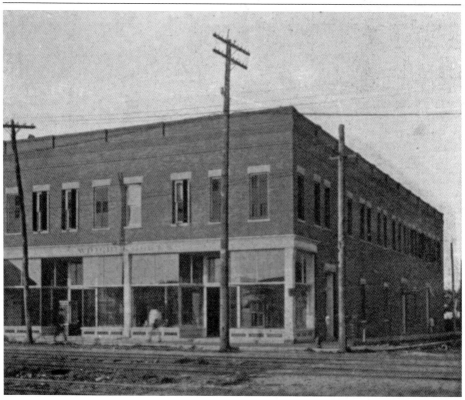

WORK AND INDUSTRY

TRANSPORT

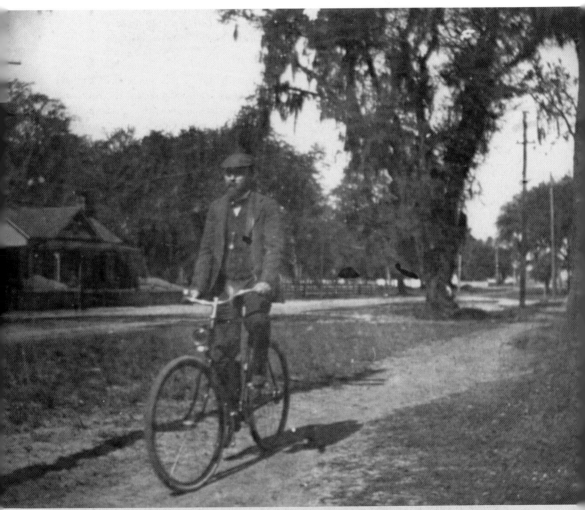

Bicycles were a new mode of transportation for getting around town at the turn of the 20th century. A streetcar also operated in parts of Brunswick. Charles S. Tait, Downing Company senior vice president, rode his bike to work each day from his home in Old Town on Dartmouth Street.

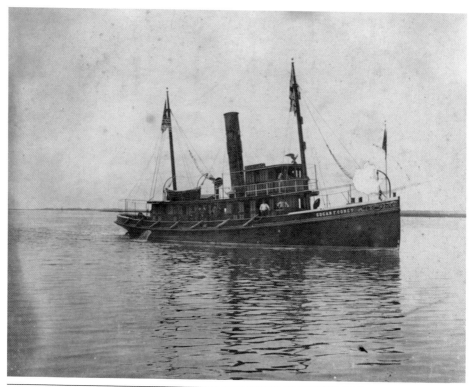

The *Edgar F. Coney* was one of many tugboats that towed ships and barges. Prior to steam-powered tugs and other boats, sailing ships used their wind power in and out of port. Early tugs competed with one another to bring in sailing ships. Tugs also towed log rafts from inland, and others were used for fighting fires. Brandy Point on Andrews Island is on the far left. Today, tugboats remain an essential part of port operations.

The steamer *A.E. Chappell* transported passengers between Brunswick, St. Simons Island, and Florida. The boat was originally purchased to navigate the Ocumulgee River from Macon to Brunswick by a company whose vice president was A.E. Chappell. It was said the boats "touched" at points in their route. Most steamers had a freight and a passenger deck. Today, passenger cruise vessels still call near Brunswick Landing Marina at Mary Ross Park. Brunswick Landing Marina sits on the East River between Gloucester and M Streets.

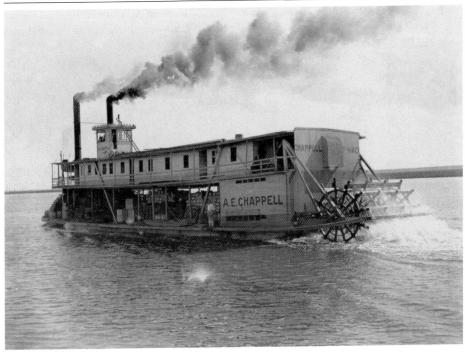

At New Hope Plantation, the old home was lost to fire and eventually replaced by newer homes over time. In the late 1920s, the extended Tait family gathered at the home of Hugh Tait and posed here with their cars for a family photograph. In this era, the many cars owned by one extended family were a sign of wealth.

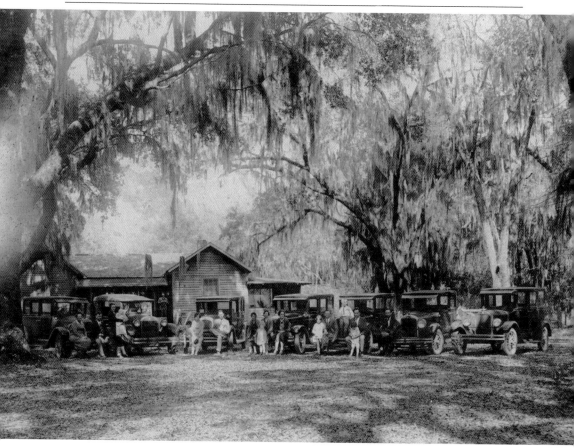

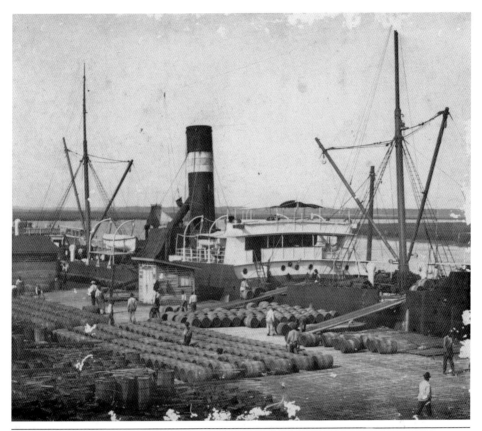

Workmen at this steamship are loading naval stores up two ramps around 1905. The boat has two cranes, a smoke stack, and several lifeboats. The Downing Company owned a large section of the East River waterfront, including the resin dock and yard at the foot of Gloucester Street and south for a full city block. Today, this is where Mary Ross Waterfront Park and the marina meet the modern port and public waterfront.

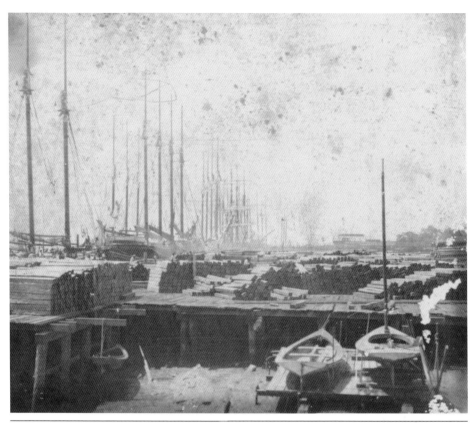

A line of tall-masted sailing vessels loads timber from the Downing Company wharf on the south side. Lumber mills in the area brought capital and jobs that created Brunswick's economic golden age. Large container ships from around the world now dock at Brunswick's East River port, known as Georgia Port Authority Mayors Point, to load and unload shipments such as poultry products.

This busy street scene in the early 1900s shows Newcastle Street just south of Gloucester Street with a streetcar in mid-transit. In its early days, this block hosted a grocery, drugstore, mercantile shops, and a second-story Masonic hall. Jekyll Square is located at the open space to the right. Today, the building with the A-frame roof on the far right is home to Tipsy McSway, one of the key businesses that jump-started Newcastle Street's 21st-century revitalization. (Past, courtesy of Bryan Thompson.)

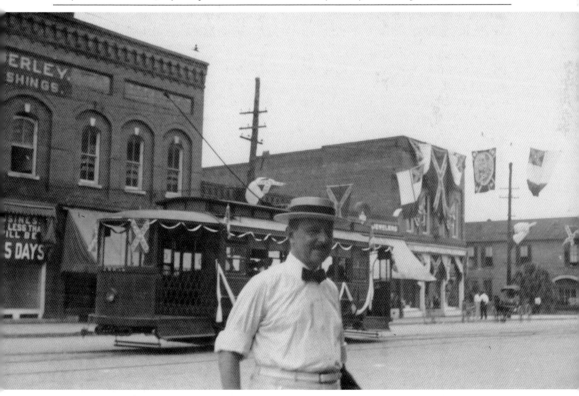

At New Hope Plantation outside Brunswick, a man and a girl traveled in a horse-drawn carriage near corn fields. The house in the photograph burned down and was replaced since then with subsequent houses. New Hope produced corn and rice and was purchased by Charles S. Tait Sr. and his brother-in-law Robert H. Parker. Tait and Parker added propagating flower bulbs for the wholesale industry.

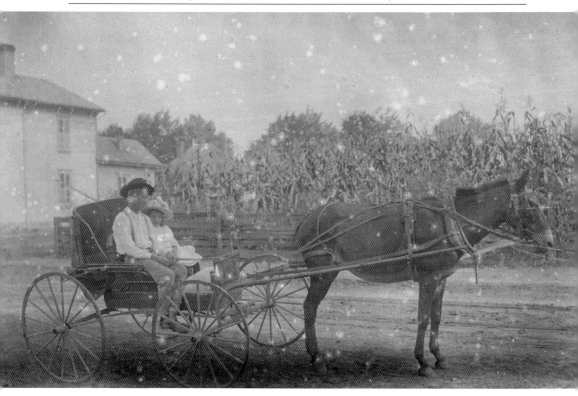

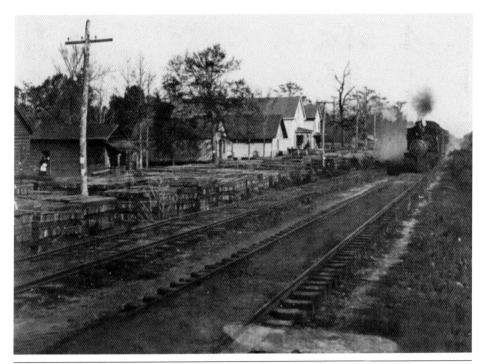

In 1908, multiple railroad companies operated in Brunswick transporting passengers as well as naval stores from the riverfront. Many tracks serviced the company wharves that lined the East River (Padrosa, Cook, and Downing Company). Additional lumber docks farther north on Academy Creek were Watson, Hirsch, Williams, Cooney & Eckstein, and Aikens Wharf. Between the homes and the tracks seen here, railroad cross ties were stacked awaiting installation. Bay Street today is a boulevard.

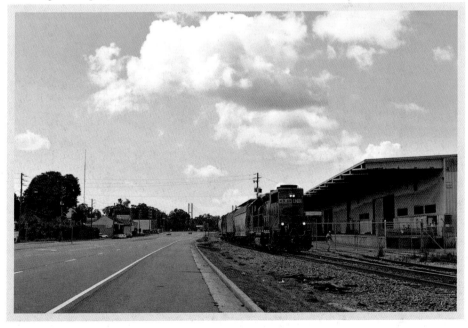

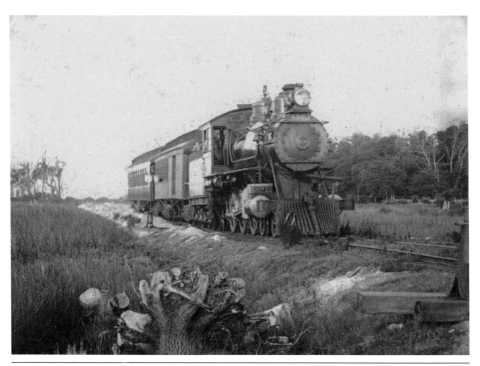

Several railroad companies operated in Brunswick at the turn of the 20th century to transport coal, timber, other cargo, and passengers. The Atlanta, Birmingham & Atlantic Railroad Passenger and Freight Company purchased 1,900 acres on the city's south-side riverfront and an additional 140 adjacent acres. Artesian wells supplied the terminal. Here, a steam engine approaches with two passenger cars and two large bells.

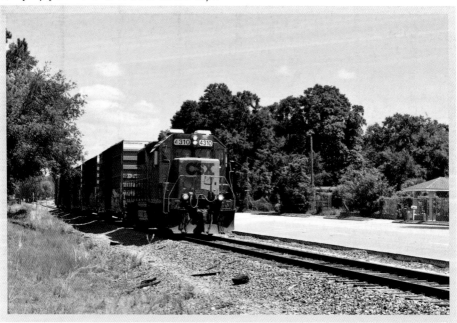

THE CHURCHES

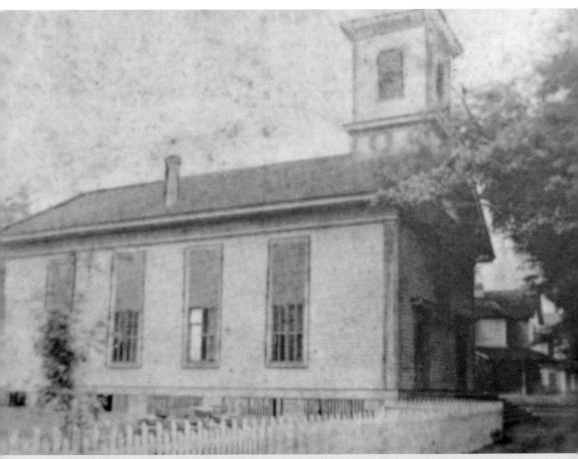

The original First United Methodist Church sanctuary was completed in 1861. Most of Brunswick's citizens evacuated during the Civil War, and services ceased until 1865. The current sanctuary was completed in 1904. The turn of the century saw many of these early simple sanctuaries replaced by the ones known today. (Courtesy of Marshes of Glynn Libraries.)

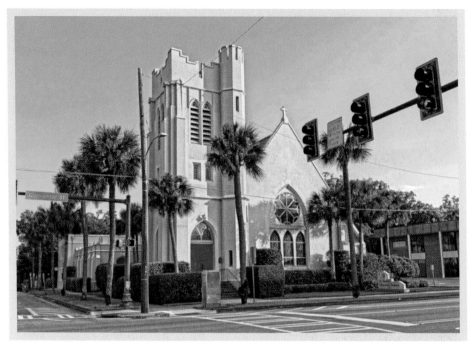

St. Mark's Episcopal Church constructed this sanctuary on Gloucester Street in 1874. Rev. Henry Lucas expanded the church, and in 1892–1893, a bell tower and nave were added. The hurricane of 1898 caused extensive damage. When beloved Reverend Lucas died in 1900, he was interred under the altar. In 1911, the current church was built with cement bricks, encasing the old wooden structure and expanding the footprint. (Past, courtesy of Marshes of Glynn Libraries.)

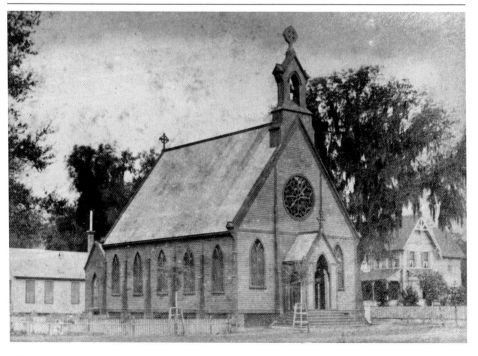

THE CHURCHES

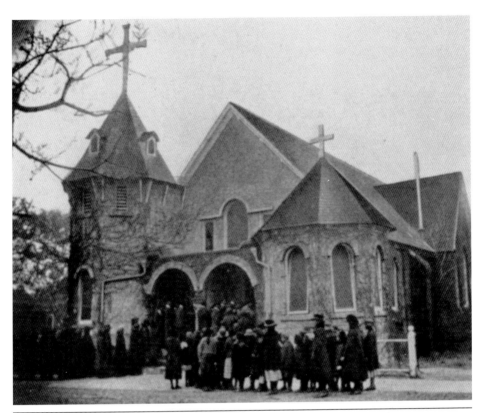

St. Mark's Episcopal Church organized St. Athanasius Episcopal Church in 1885 from a black Sunday school group. Students are seen here attending daily services from the church-run St. Athanasius School next door, which grew steadily and focused on domestic science, manual training, and industrial arts. A lack of funding forced the school to close its doors permanently in 1928, but St. Athanasius Church is thriving today. It is one of the few tabby structures remaining in Old Town. (Past, courtesy of Josh Dukes.)

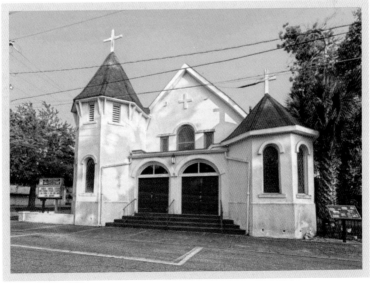

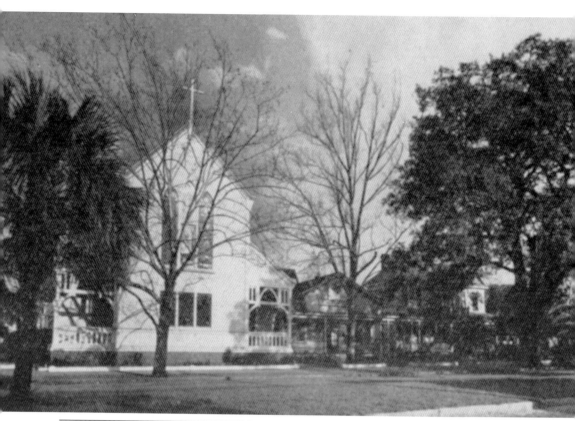

In 1884, Bishop William Gross dedicated St. Francis Xavier Catholic Church. During the yellow fever epidemic of 1893, Fr. Joseph Hennessey refused to leave town, despite others doing so. He went from house to house to give aid to anyone in need. The 1898 hurricane and flood destroyed almost all of the windows. Under Fr. Paul Burkort, the church, rectory, and hall were razed in 1958 and the modern church's sanctuary was constructed. (Past, courtesy of Marshes of Glynn Libraries.)

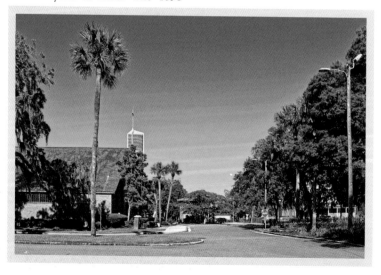

THE CHURCHES

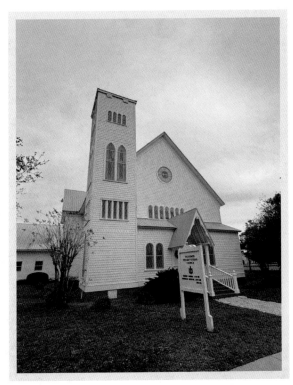

Second Advent Christian Church held its first service in this building in 1904 after a land exchange with the city. This building replaced an older Baptist church at the same location. Second Advent was originally located on the north side of H Street facing Magnolia Square and the Glynn County Courthouse. The sanctuary was moved across H Street in preparation for a courthouse complex expansion and rededicated in 1989. The original spire is no longer attached to the steeple.

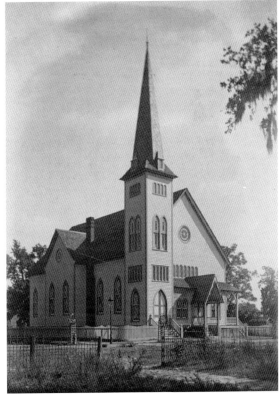

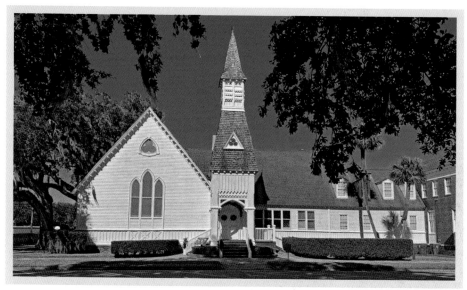

The First Presbyterian Church on George Street was constructed in 1873 from a design by architect George W. Lane. The interior pine beams, doors, and windows were sent to Boston to be finished because no planing mill existed in the city at the time. In 1893, the sanctuary was enlarged and a manse was built next door. To make room for a new education building, the manse was moved across Union Street in 1952 (see page 41 for manse photographs).

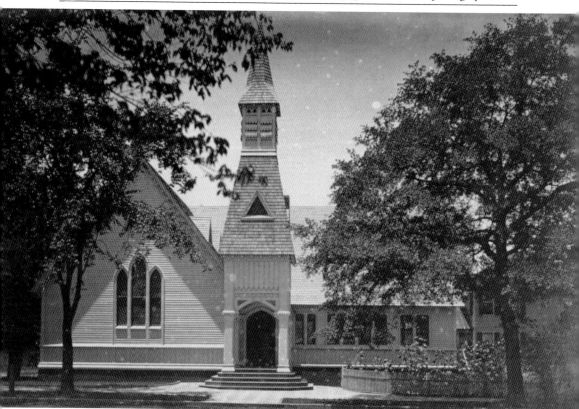

THE CHURCHES

The Brunswick Methodists worshiped in various locations including the 1840 Glynn Academy schoolhouse before building their first church at 1400 Norwich Street in 1861. The original wooden church was removed in 1904, and construction began on the current brick church at 1400 Norwich Street. Behind the altar is an inset Cross of Passion in faceted glass. In the years since, an educational annex, an addition, and a welcome center have been added.

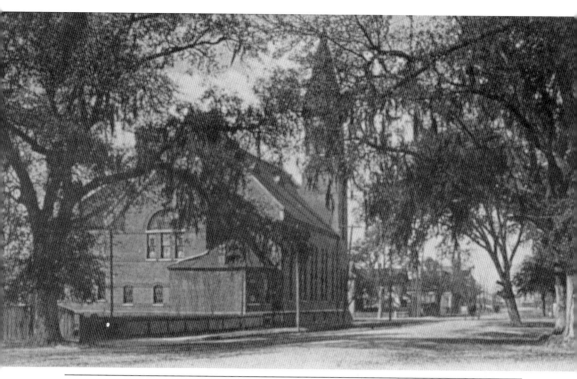

In 1890, Brunswick First Baptist Church completed a double-steepled sanctuary at the corner of Union and Mansfield Streets. A tidal creek ran from the East River up Mansfield Street, and many parishioners crossed via a wooden bridge near Reynolds Street. This c. 1900 view looks down Mansfield Street after the creek was filled. In 1967, the church broke ground on a new sanctuary across the street. The old First Baptist sanctuary was replaced with an education building. (Past, courtesy of Josh Dukes.)

THE CHURCHES

ENTERTAINMENT AND LEISURE

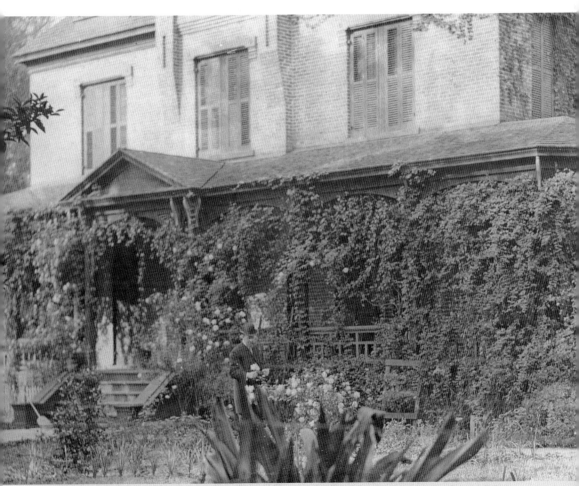

Maj. Columbia Downing (1845–1924) admires his flowers in front of his Egmont Street mansion. Downing, a busy and prominent businessman, enjoyed his gardens. Gardening was one of many local pastimes, including parades, fishing, boating, escaping to a beach retreat, joining numerous social clubs, or cooling off in a local tidal creek.

Robinson's Circus was a frequent visitor to Brunswick in the early 1900s and was often set up in what is now Windsor Park. Part of the arrival in town included a grand march down Newcastle Street. This over-the-top circus based out of Cincinnati, Ohio, included elephants, teams of horses, camels, and various performers. The whole town turned out to see the spectacle. This intersection of Mansfield and Newcastle Streets now features a renovated Queen Square on both sides of Newcastle Street.

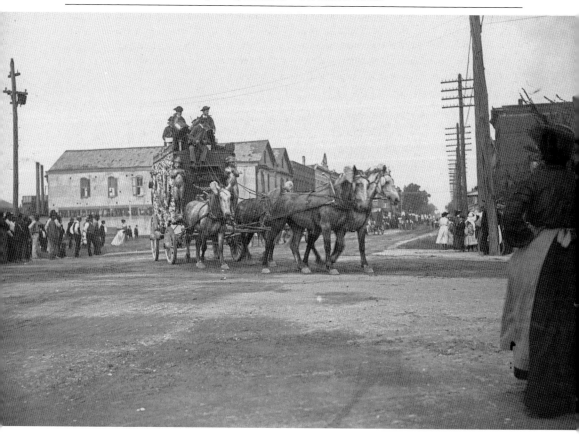

Entertainment and Leisure

In 1910, Capt. Frank D.M. Strachan bought Retreat Plantation, on the south end of St. Simons Island, and built a summer cottage for his family to escape from their Union Street residence in Brunswick. Known as Beach Lawn, the home was moved by barge to Daufuskie Island, South Carolina, in 1986. A two-story carriage house remains on St. Simons today. The original site became a new development with multiple homes in the late 1980s.

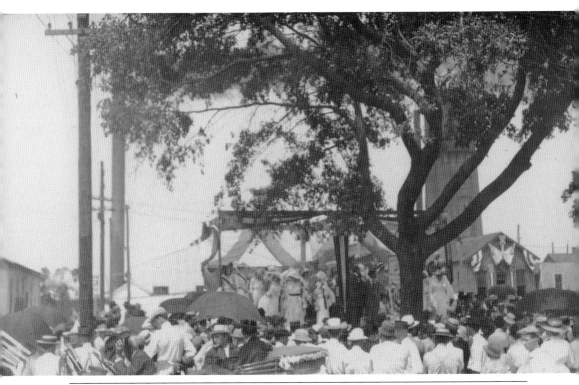

This post-parade gathering shows the view at Machen Square looking west across Grant Street. The tall chimney to the right was the Mutual Light and Water Company plant, which sat at the corner of Oglethorpe and F Streets. Nearly everyone wore hats in this era. Today, Machen Square is one of Brunswick's many landscaped "pocket parks" along Newcastle Street. Many events such as concerts and craft fairs continue to use the squares. (Past, courtesy of Bryan Thompson.)

ENTERTAINMENT AND LEISURE

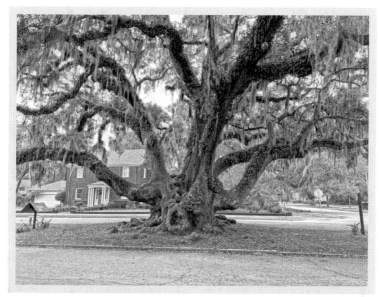

The Lover's Oak has a trunk girth of 35 feet and reportedly dates to the 12th century. Its name comes from a much-retold legend of natives Netowah and Minnie-Wassie who met in secret under the tree. Mistakenly thinking she had fallen for another, Netowah took Minnie-Wassie's life and his own with a knife through the heart. Her heartbroken father buried them under the tree. Visitors still flock to see the ancient oak at the corner of Albany and Prince Streets.

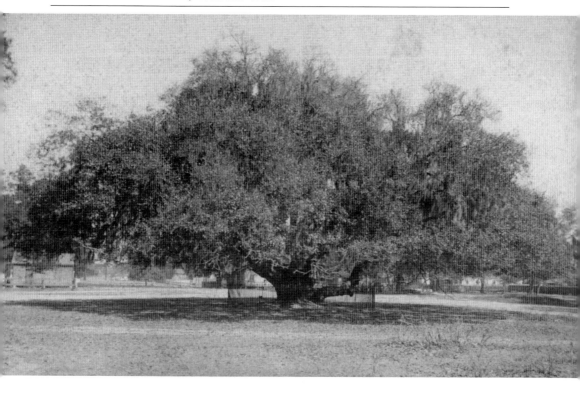

Children dressed in their fine clothes are gathered on the Old Jesup Road bridge over the Brunswick-Altamaha Canal. The canal was a 12-mile-long channel built to connect the Altamaha River to Brunswick at the Turtle River to transport goods inland. Construction continued from 1836 to 1854 using free and enslaved workers, with one exciting dig turning up the remains of a Columbian mammoth. The canal was short lived and closed in 1860 as new railroads across the area made it obsolete.

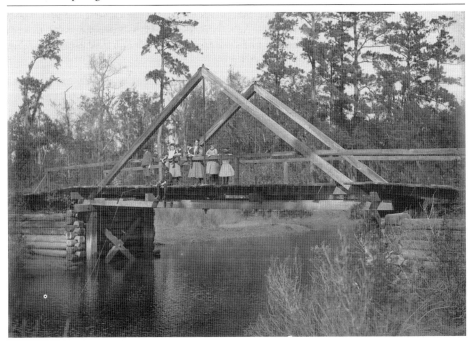

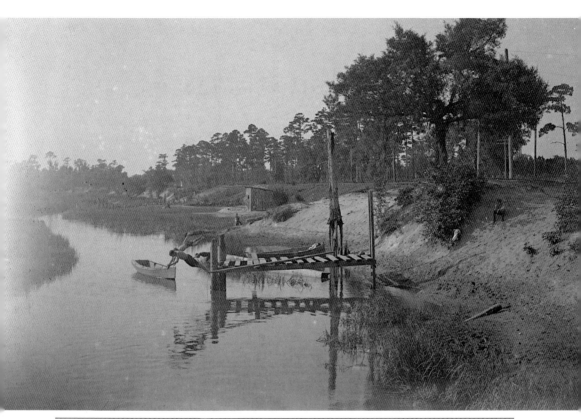

A small dock on Academy Creek provided a place for children to swim near one of the rail lines leaving downtown Brunswick. The photographer captured boys diving mid-motion. In the mid-1970s, Academy Creek was dammed just north of the photograph to prevent silt buildup along the port. Today, Brunswick Landing Marina uses this peaceful tidal area as a harbor for recreational boating.

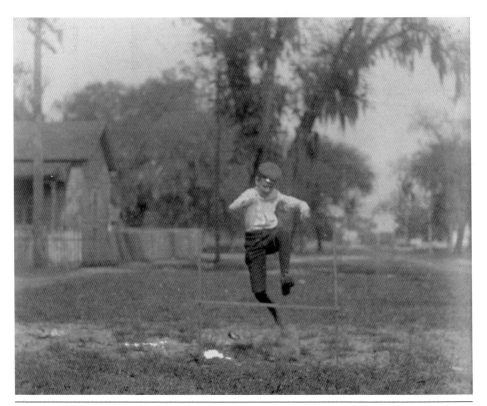

Young Downing Tait was captured mid-leap by his father's camera as he maneuvered a hurdle along Dartmouth Street. The Tait home was located to the left of this image. The small freedman's cottage in the background was a modest home that sat where Albany Street met Norwich Street. While the Tait yard remains, the freedman's cottage and many like it have since vanished from Old Town. A movement to save and restore some of the cottages continues today.

ENTERTAINMENT AND LEISURE

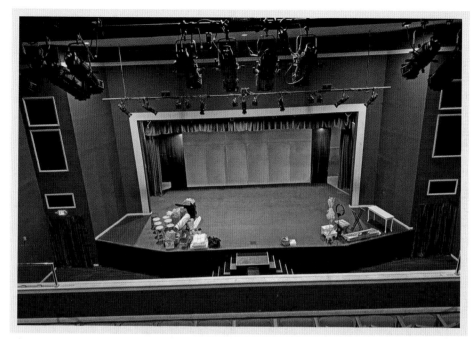

The Grand Opera House hosted its first performance on September 18, 1899, featuring the Brunswick Riflemen. Opera boxes flanking the stage were removed when the Grand was reinvented as the Ritz, an Art Deco movie house. Falling into disrepair and even losing its roof in the 1990s, the auditorium was restored and is now the headquarters for Golden Isles Arts and Humanities. The Ritz Theater continues to pack the house for shows today. (Past, courtesy of Golden Isles Arts and Humanities.)

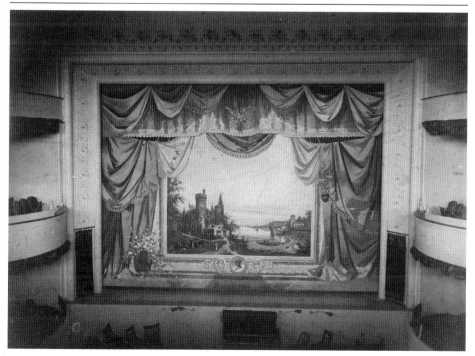

DISCOVER THOUSANDS OF LOCAL HISTORY BOOKS FEATURING MILLIONS OF VINTAGE IMAGES

Arcadia Publishing, the leading local history publisher in the United States, is committed to making history accessible and meaningful through publishing books that celebrate and preserve the heritage of America's people and places.

Find more books like this at
www.arcadiapublishing.com

Search for your hometown history, your old stomping grounds, and even your favorite sports team.